The Campus History Series

COTTING SCHOOL

D1398298

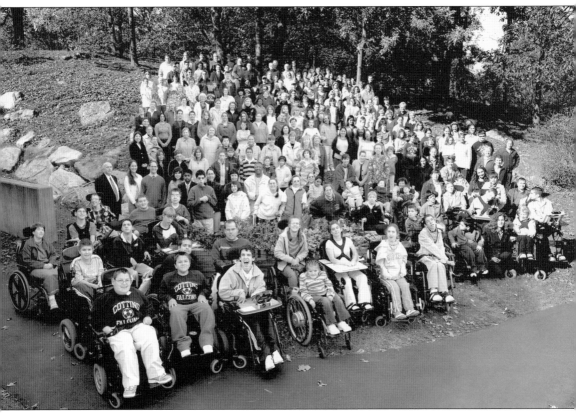

The above photograph of the students and staff of Cotting School was taken in 2005. Founded in 1893, Cotting School is America's first day school for children with a broad spectrum of learning and communication disabilities, physical challenges, and complex medical conditions. Cotting School serves 130 day students between the ages of 3 and 22, from 74 Massachusetts and southern New Hampshire communities, and provides residential services to 8 young adults at HOPEhouse. (Courtesy of Martha Stewart.)

On the cover: The cover photograph of Mary Perry, the school's first teacher and superintendent, along with her seven students, was taken in 1904. (Courtesy of Cotting School Archives.)

The Campus History Series

COTTING SCHOOL

DAVID MANZO AND ELIZABETH CAMPBELL PETERS

ARCADIA
PUBLISHING

Published by Arcadia Publishing
Charleston, South Carolina

Printed in the United States of America

Library of Congress Catalog Card Number: 2007935578

For all general information contact Arcadia Publishing at:
Telephone 843-853-2070
Fax 843-853-0044
E-mail sales@arcadiapublishing.com
For customer service and orders:
Toll-Free 1-888-313-2665

Visit us on the Internet at www.arcadiapublishing.com

With gratitude for lessons learned from our students and their families about exquisite kindness, perseverance, and passion for life; from our staff about innovative care and quality services; from our trustees about generosity and wisdom; and from my family, especially Noreen and Lou, about love, patience, and understanding.
—David W. Manzo

This book was made possible because of my current colleagues and those who came before me. I am extremely grateful for their support.
—Elizabeth Campbell Peters

CONTENTS

ACKNOWLEDGMENTS

We are indebted to the following individuals for their wisdom, insight, editorial skills, and encouragement: former superintendents William Carmichael and Carl Mores; former students Arthur and Geri Downing; trustees John Chaves and David Lee; current staff members Beth Andersen, Ginny Birmingham, Linda Byam, Bridget Irish, Krista Macari, George Moran, John Navaroli, Jim Tanner, Pam Varrin, and Sara Yun; and friends Les Acox, William T. Anderson, Charles Bradford, Lucinda Lee, Noreen Manzo, Pat Mullaly, Brandt and Sandra Pace, and Martha Stewart. The following individuals and organizations also provided important historic information: Pam Schwotzer, Amesbury Public Library; Sally Pierce, Boston Athenaeum; Aaron Schmidt, Boston Public Library; Tracy Messer, Crotched Mountain; the Library and Archives of the Episcopal Diocese of Massachusetts; Tracy Potter, Massachusetts Historical Society; Portsmouth Athenaeum; Portsmouth Historical Society; Michael Huxtable, Portsmouth Public Library; Mylinda Woodward, University of New Hampshire Milne Special Collections and Archives; Peter Crosby, University of New Hampshire Dimond Library.

Sources used in the book include the Cotting School Annual Reports from 1894 to 2006 and *A History of Cotting School 1893–1993* with Allison Ridley Evans as editor. This book was made possible thanks to a grant from U.S. Trust, Bank of America Private Wealth Management. To learn more about Cotting School, please visit www.cotting.org. The school is located at 453 Concord Avenue, Lexington, Massachusetts 02421. Please call (781) 862-7323 for a tour.

INTRODUCTION

Will you, gentle reader, bring your friends to see the School?
They will be amply rewarded.
—Cofounder Dr. Augustus Thorndike

Since its founding as the Industrial School for Crippled and Deformed Children in 1893, Cotting School has been a leader in the evolution and revolution of improving services for children with special needs.

Using photographs from the Cotting School archives, this book chronicles the last century's shifting attitudes toward, and the innovations for, education and services for children with disabilities. For example, the school's name has changed from the Industrial School for Crippled and Deformed Children to the Industrial School for Crippled Children (1948), to Cotting School for Handicapped Children (1974), to Cotting School (1986).

A 21st-century reader might look harshly on the terms "crippled" or "deformed," used by the early leaders and found in captions of photographs in this book. Yet the founders and early leaders of the school were progressive and caring women and men, and their language reflects the times in which they lived.

Dr. Augustus Thorndike's generous invitation to "you, gentle reader" to visit the school appeared in the 1901 annual report. Dr. Thorndike knew the school would be a place of contradictions and surprises for the visitor. He recognized that sometimes things are not always what they appear to be. Visitors to the school in the 19th, 20th, or 21st centuries might have expected to see children who were cheerless and staff who were tired. From his experience, Dr. Thorndike knew the opposite would be true, for at Cotting School, the students are happy and thriving, and the staff is energized and creative. He understood, too, that by meeting students, visitors would learn to appreciate the unique gifts and strengths of each child, as he or she was fully and productively engaged in all aspects of learning.

Anticipating that educating and challenging the bright young minds of children with disabilities would lead to engaged, independent, and productive adults, Drs. Edward Bradford and Augustus Thorndike gathered seven men to form a corporation in 1893 "for the purpose of promoting the education and special training of crippled and deformed children." Dr. Bradford summed up his philosophy as he sought support for this new venture: "The worst thing you can do for anybody is to give them the egotism of self-pity. To eliminate this is the object of our School."

Drs. Bradford and Thorndike were committed to innovation, quality, and humility. When asked about the school's founding, each would give full credit to the other.

In the fall of 1894, the Industrial School for Crippled and Deformed Children opened in a donated basement space at St. Andrew's Parish House, 38 Chambers Street, Boston,

Massachusetts. There, volunteer Mary M. Perry served as the school's first teacher and superintendent for seven students. With a full day of academics, a noon meal purchased on credit extended from S. S. Pierce, and a horse-drawn carriage on loan from the Armstrong Livery Service to transport students, America's first private, free, day school for children with disabilities was born.

With an increased enrollment of 15 students and 7 more on the waiting list, the school moved to 6 Turner Street in the Back Bay section of Boston in 1895. A year later, with 36 students enrolled and an additional 16 on the waiting list, the school had moved to still larger quarters at 424 Newbury Street.

Thanks to careful management by Drs. Bradford and Thorndike and board chairman Francis Joy Cotting, within 10 years the school was housed in a debt-free, magnificently constructed building on St. Botolph Street. By 1907 the trustees bought land adjacent to the building to serve as a playground, and by 1911 the school accommodated 100 pupils. Tuition, a hot lunch, and transportation continued to be free. In 1922, additional property was purchased on St. Botolph Street, and by 1926 a new building more than doubled the size of the school, enabling extensive vocational training programs to be offered. In 1987, under the leadership of president Carl Mores and board chairman William Taylor, Cotting School sold the Boston property to the New England Conservatory of Music and moved to Lexington, where a 14-acre campus in a country setting provided students the opportunity for more outdoor recreation and a new, spacious, fully accessible, light-filled facility.

Four families are noted for their service to the school: the Bradfords, Thorndikes, Cottings, and Taylors. Drs. Thorndike and Bradford volunteered their expertise for a combined 82 years. Members of both of their families continue to serve the school. Francis Joy Cotting, who, like the school's students, was disabled, served as board chairman from 1897 to 1914. Then, from 1922 to 1984, his nephew Charles E. Cotting served as trustee, treasurer, chief fund-raiser, philanthropist, and wise, prudent leader during the economic uncertainties of the Great Depression and World War II. Yet another major family of the school is the Taylors of the *Boston Globe*. Charles Taylor Sr., his son Charles Taylor Jr., and his cousin William Taylor served as board presidents from 1933 to 1986.

For much of the 20th century, cultural and architectural barriers as well as lack of good teacher and administrator training limited public school access for students with disabilities. Cotting School filled that educational and therapeutic need for children in metropolitan Boston. Since 1893, many of America's most innovative teachers, therapists, nurses, doctors, and support staff have come to work at Cotting School. Because polio and Pott's disease have been eliminated, the children served today have different needs than the children of the late 1800s, 1920s, and even the 1950s. Yet Cotting School has always remained true to the cofounders' commitment to innovation and quality.

Thanks to generous donors who have made annual contributions and bequests, Cotting School continues to provide groundbreaking and effective services to children with a broad spectrum of learning and communications disabilities, physical challenges, and complex medical conditions.

One

THE WHOLE CHILD

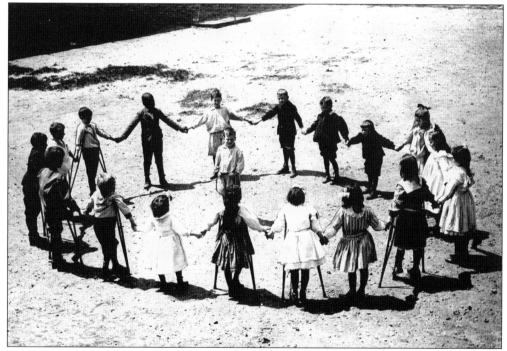

Students come to Cotting School with a broad spectrum of learning disabilities, communication impairments, physical challenges, and complex medical conditions. To meet their diverse educational needs requires programming that focuses on the whole child. Cotting does more than simply create interventions to target a student's diagnosis or disorder. It designs a continuum of educational, therapeutic, and support services to ensure that the students and their families become part of a "comprehensive classroom" within an extended learning community. The photographs in this chapter offer a glimpse of the wide range of innovative services that have been offered to students since 1893.

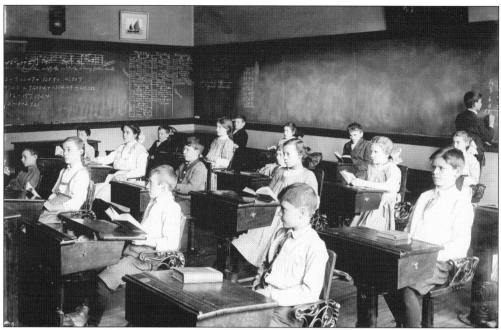

From the school's inception in 1893, Supt. Mary Perry and her staff designed a curriculum to meet the complex and changing needs of its students. The 1906 summary of facts about the school is shown below. The school's curriculum and services have evolved with each new technological, educational, therapeutic, and medical breakthrough.

SUMMARY AND FACTS.

Purpose : A free school to promote the education and special training of the crippled and deformed.

Education : Primary and grammar departments, with grades similar to those of public schools. Manual training adapted to these grades, including paper folding, clay modelling, palm basket making, sloyd carpentering, cane-seating, reed basket making, needlework, cobbling, type-setting and printing. School hours nine A.M. to four P.M. Most of the pupils are brought to school in carriages, and receive a good substantial dinner at noon.

Special Training : Trade classes for persons over fifteen years. The trades taught are type-setting and printing, cane-seating and basket work and needlework. As soon as proficient these workers receive pay. The work for these trades is provided from orders received by the school. Application blanks may be had by writing to F. J. C., P. O. Box 1155, Boston, Mass.

Support : At present there is but a very small endowment, and the work therefore depends very largely upon the yearly contributions.

Treatment : Members of all departments receive the attention of a nurse. For medical and surgical treatment the pupils attend the clinics of the various hospitals ; also visits are made regularly by the Medical Committee.

These facts may be found elaborated in the reports of the various committees.

A sampling of leg braces and adjustable devices used by children at the school, this undated photograph was taken when the school was located on Newbury Street, between 1897 and 1904. Note the harness attached to the overhead tracking system, which was used to hoist and support students during physiotherapy.

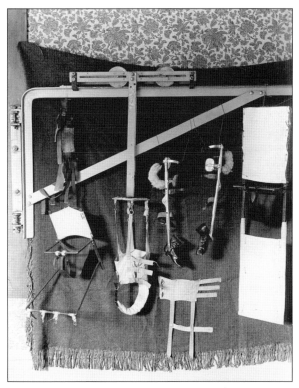

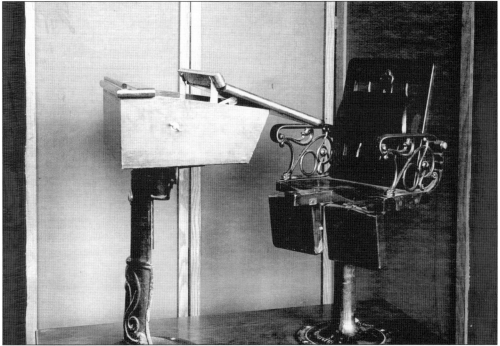

Adapting educational equipment to meet the physical needs of the students began with the founding of the school and continues today. The adjustable heights and angles of desks and chairs greatly assisted students in the classroom.

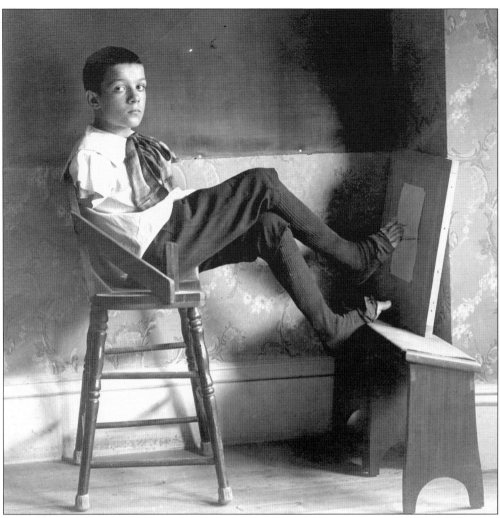

Frank Gardello, pictured here in 1901, wrote about himself, "My name is Frank. I am 11 years old. As I was born without hands, I am learning to use the typewriter with my toes. . . . I can play football, play on a little toy piano, and can ride a bicycle." Later Gardello graduated from high school and became a messenger for Western Union and an active member of the school's alumni association.

In 1898, Francis Joy Cotting wrote of the efforts to assist the student pictured here: "Owing to his being extensively paralyzed by a broken back, he receives lessons at his home. A friend of the School gave $50 to be used to pay his teachers. He seems to greatly appreciate what the School has done for him. From his picture you will see the position, which he has to be in most of the time. Doctors connected with the School are now trying to see if it is possible to arrange for him to use a wheelchair, but he has been so many years in his present condition that it is very hard to make a change. He was injured at the age of eight by a horse-car."

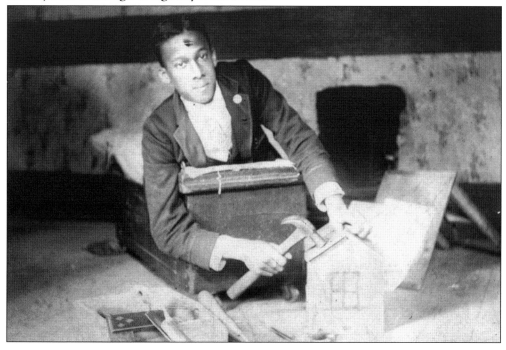

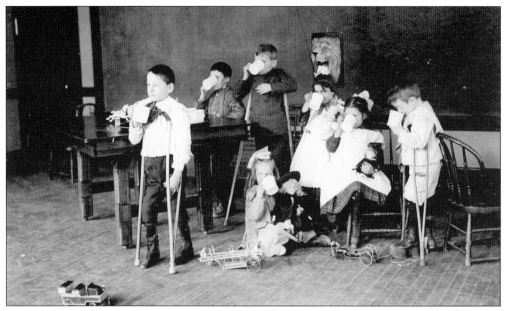

In the early years many of the students were malnourished. Some families had to choose between buying fuel, food, or clothing. Often the Ladies Committee assisted families with funds for fuel and rent; members also donated food such as sacks of apples or potatoes to the school kitchen. Twice each day children were fed milk for proper nourishment and strength. This photograph of an afternoon snack was taken in 1904.

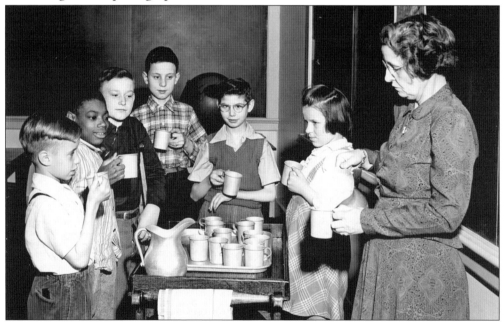

Children were still receiving extra milk and snacks to ensure proper nourishment in the 1940s. Milk distribution and consumption was the first task of every day. At the beginning of the school year, some students were weak from improper nutrition and lack of exercise. Several months later they showed weight gain and improved muscle tone and general health. (Courtesy of George M. Cushing Jr.)

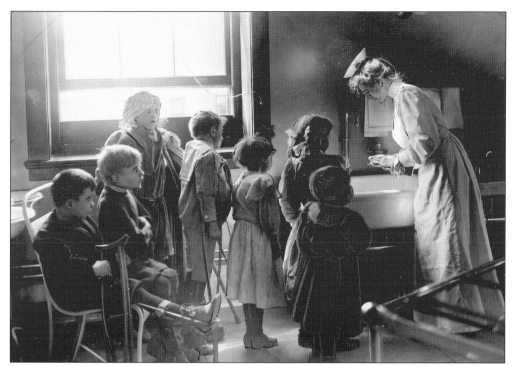

In 1909, a daily dose of cod liver oil was given to each child. Parents were instructed in proper hygiene for their children. Suggestions included caring for lice nits, keeping bedroom windows open, getting proper rest, and maintaining personal cleanliness and clean underwear; consequently, healthier students began arriving at the school.

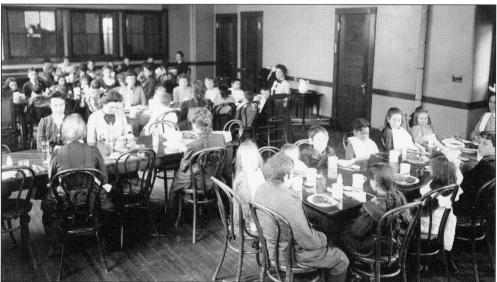

From the school's inception, a hot meal at noontime was as important for students as their instruction. Supt. Mary Perry insisted upon "a good plain dinner" and noted its effect upon her charges as "once listless invalids really began to show signs of mischief and childish faults." This 1905 photograph shows the model of family-style meals with an adult present at each table. This practice continues at Cotting School today.

In 1928, Supt. Vernon Brackett wrote, "It is very noticeable how some of the children will unfold after a few weeks attendance at the school. A shy, quiet child who has been kept very closely at home, has had no contact with other children nor opportunity to play with others, enters the school and is very unwilling to take part in group activities. It is only a few weeks before he is not noticeable, because he has mingled himself in the group, playing and shouting as lustily as any. Also, a child who is very badly crippled and has not been allowed to do for himself in the home because the kind parents thought he was unable, will see others as badly handicapped as he is doing things which he has not been allowed to attempt and it is not long before he is doing these same things." These photographs of enthusiastic students are from early- and mid-20th-century Thanksgiving celebrations.

In this 1931 photograph, a student uses an assistive device at lunch. Dr. James Warren Sever commented on the effectiveness of the school's philosophy in his 1937 medical report: "It was found on testing the children here in the School that due to the physiotherapy treatments, the opportunity to participate in plays and games, and the program of having each child do for himself everything possible without assistance, our children rated much higher than children who were tested who were not in attendance at this School."

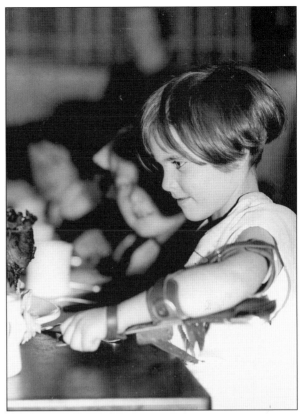

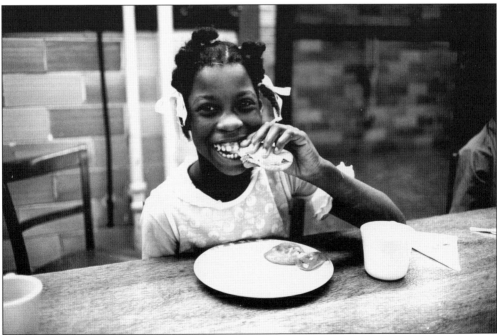

Lunchtime is as much about proper nutrition as it is about social skills and having conversations at the lunch table, as depicted in this 1980s-era photograph.

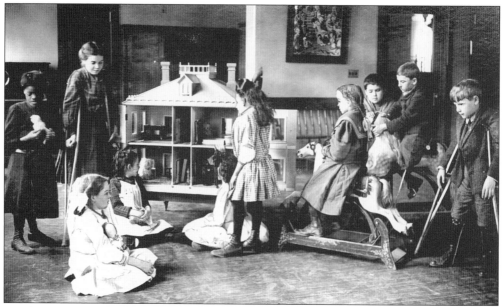

Teacher and superintendent Mary Perry made certain that children were given time to play and to learn the socialization skills that are involved in such interaction. In addition to a solid academic schedule, children were given time to be children and to develop as typically as possible. Here in 1907, children ride rocking horses and play with dolls and dollhouses, just like their typically developing peers.

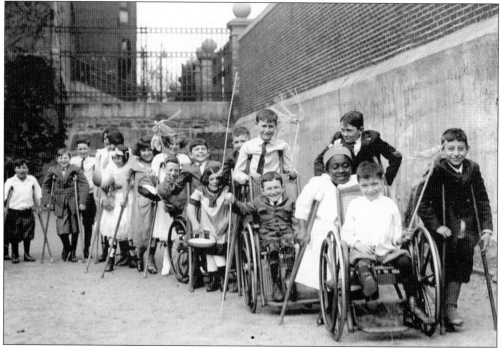

Parading around the playground at the St. Botolph Street school building, these children are getting exercise without calling it that. The 1924 annual report entitled this photograph, "A Group of Happy Sunbeams."

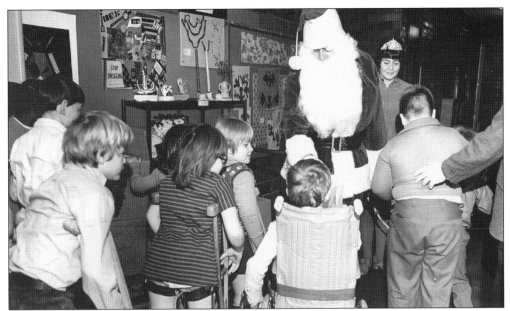

Commencing at the school's founding, annual holiday parties complete with a Christmas tree, Santa Claus, Hanukkah decorations, and entertainment have been a Cotting School tradition. Here Santa hands out gifts as he makes the rounds in the 1960s, and a clown entertains some delighted children in the 1950s. Supt. William Carmichael recalls Boston fire regulations calling for firemen to be present and a bucket of sand on hand in case of fire. Not wanting to disturb the children with the presence of firemen, he resolved the problem by decorating the tree outside and bringing it in at the last minute for the duration of the program, after which he whisked it outdoors again and avoided the presence of the firemen.

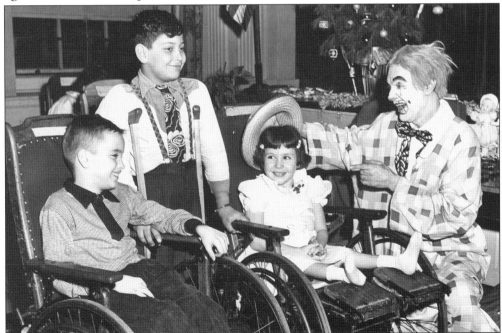

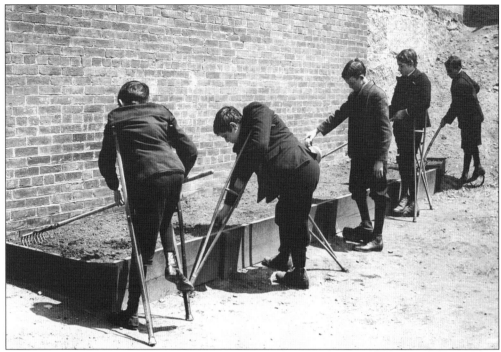

Francis H. "Hooks" Burr wrote in the 1979 annual report, "Since its inception, the school has recognized the need for a holistic approach to the particular needs of its students. Education at Cotting School goes far beyond the interaction of student and teacher in the classroom. Extracurricular activities, medical support, therapies, special clinics, social development and physical development are all essential parts of the Cotting experience. Exploring government, nature, business, and culture ensure a broad view of the world. We teach skills for the job market—researching where that market is—and we teach learning skills for higher education. We build confidence and we instill hope for a secure future. The aim of all our programs is to ensure maximum independence for our students when they become adults." In the 1907 photograph above, boys are gardening, and below, in 1913, students dance.

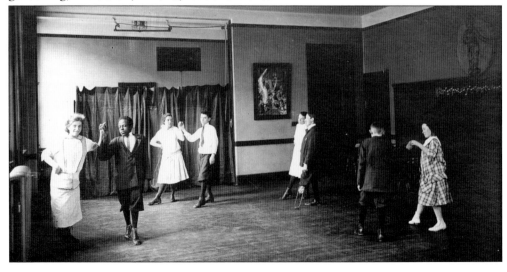

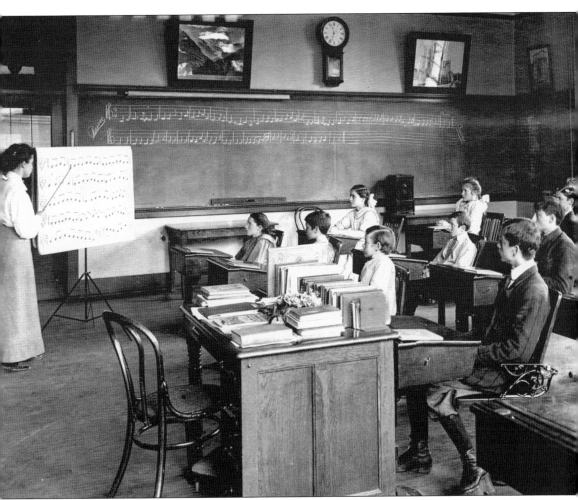

In 1917, Supt. Mary Perry wrote, "The Boston School Committee has this year placed the School on the list of private schools whose pupils may be admitted to the public high and Latin schools without examination. A class of seven was graduated from the grammar department of the School in June. Most of them intend to enter one of the Boston High Schools."

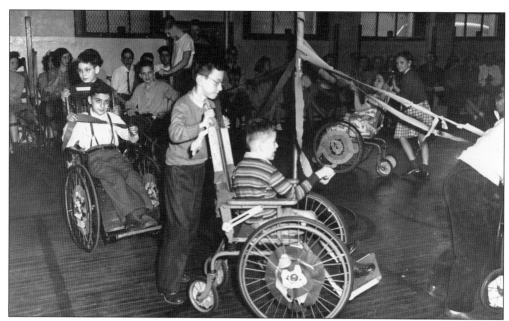

These 1950s-era photographs demonstrate how a creative faculty can keep children exercising. In the 1928 annual report, Dr. Augustus Thorndike wrote, "Games have done wonders for some cripples, not only to develop alertness, quickness, and accuracy, but to inculcate the idea of team play, which is to subordinate self to the exigency of the team and the game. All cripples harbor a horrid conviction, unconsciously fostered by coddling, that as they are not like other boys and girls, they will never be good for anything. Once a cripple has overcome this and becomes self-reliant, there is no limit to his ambitions; he wants to fit himself to do anything and everything, and his teachers have only to guide him into some field where he can excel in spite of his particular handicap." (Below, courtesy of George H. David Studio.)

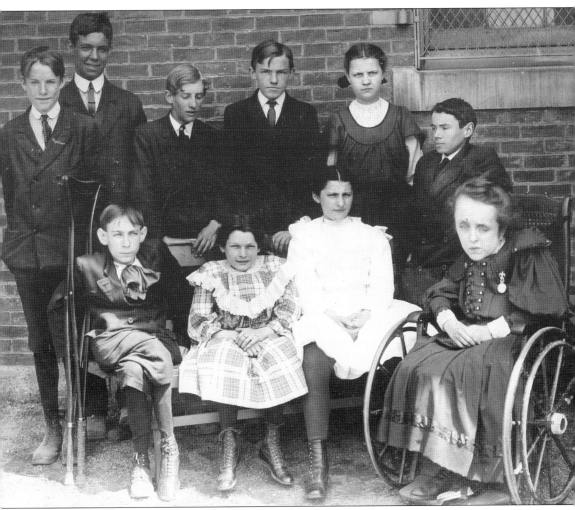

A 10-year-old male student wrote, "When I first came to this school, the doctor said I could never walk. Everywhere I went I had to be carried. First the nurse had me stand between two tables and pretty soon I was able to walk around them. Then the nurse held me and I could lift up the crutches and swing my feet a little. The next thing I could stand up alone a second. After I did this a little while, I could stand a few minutes. I had great praise the first day I took eight steps. Now I take over a hundred steps. I think the school has done a great deal for me."

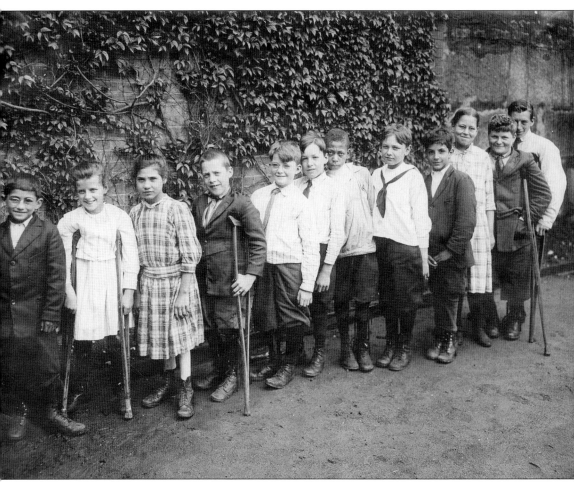

A 19-year-old female student wrote, "When I was two years old I was stricken with infantile paralysis which left me so badly crippled that I was unable to attend the public schools. I learned to read when I was about five years old, and though I read a great deal, I had no other education until I was sixteen years old. In 1919, Dr. Low arranged for me to enter this School. At that time I was firmly convinced that I was both helpless and hopeless. I had no self-confidence and believed that I should be dependent on someone the rest of my life. Now I am just as firmly convinced that I shall be able to fill an office position when I am graduated, and become self-supporting. I have taken stenography and typewriting and have had the added advantage of gaining practical experience in the office during the summer."

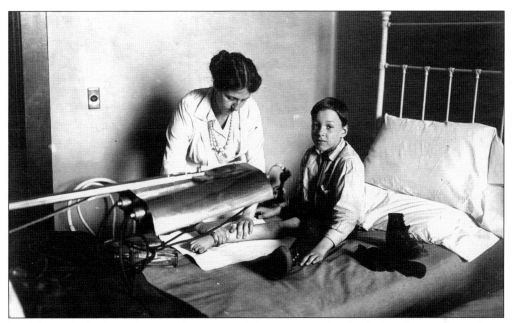

In this 1916 photograph, a student is receiving massage for his infantile paralysis. Supt. Mary Perry's annual report mentions the massages donated by a nearby school: "Massage has been given by teachers and pupils from Miss Colby's School for Gymnastics. This work has been most conscientiously carried out; and Miss Colby, her teachers and pupils, should receive praise and thanks for their work."

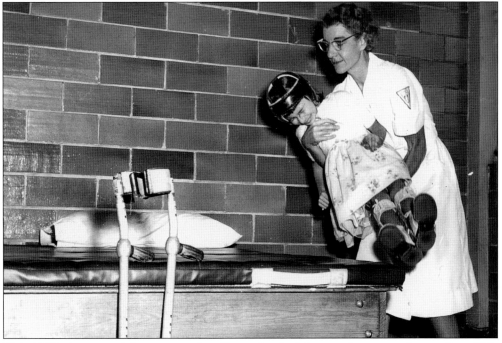

This 1958 photograph is an example of how physical therapy improves the quality of life for a student. When Charles Cotting noticed the benefits of an electric physical therapy table for both the student and the therapist, he quietly purchased one for the school.

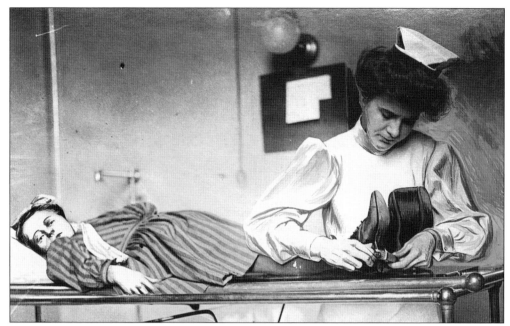

In 1917, Dr. James Warren Sever reported on the benefits of massage: "The medical work at the School has gone on as usual this past year. We have been fortunate in escaping epidemics, which might have kept many children out of School. The dental work has gone on as before, much being accomplished, and the growing importance of the work is recognized. A helper has been provided in connection with the gymnastic work who gives all her time to massaging and muscle training in the cases of Infantile Paralysis. She has been of great assistance, and the need for such a person is evident in the good results she obtained."

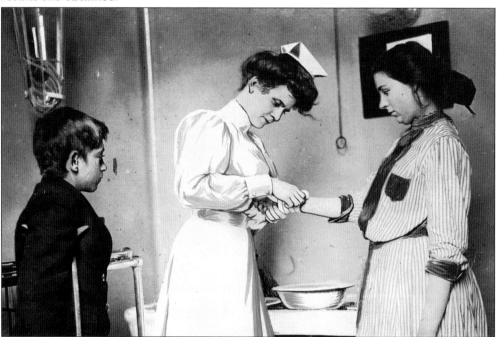

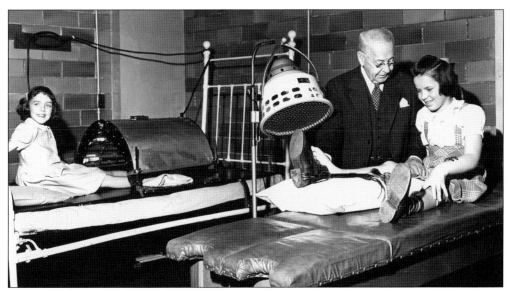

While caring for children with polio in these 1930s photographs, Dr. James Warren Sever insured that each child's treatment was continuously evaluated. In 1937, he wrote, "Without the Department of Physiotherapy, the work would largely be of a routine character, but with the many infantiles that we have in the School and the necessity for the continuation of their massages and exercises in connection with the clinics from which they come, the work is really very heavy. The constant checking of these children in relation to their exercises and their apparatus constitutes a considerable part of the medical department's time. Although officially the department has only one person in charge of it, she has to have fifty assistants, [graduate students] . . . whom we train as far as possible in this very important work in connection with crippled children, which they really can't get satisfactorily elsewhere." The photograph below documents the graduate student interns from Boston universities massaging the legs of polio victims, and the line of students waiting their turn. (Above, courtesy of George M. Cushing Jr. Photography.)

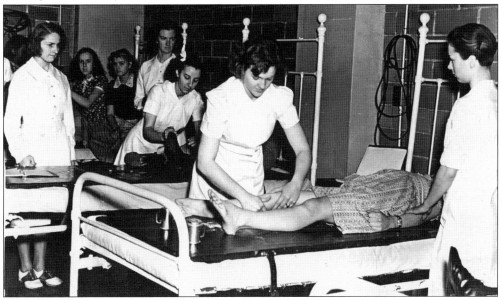

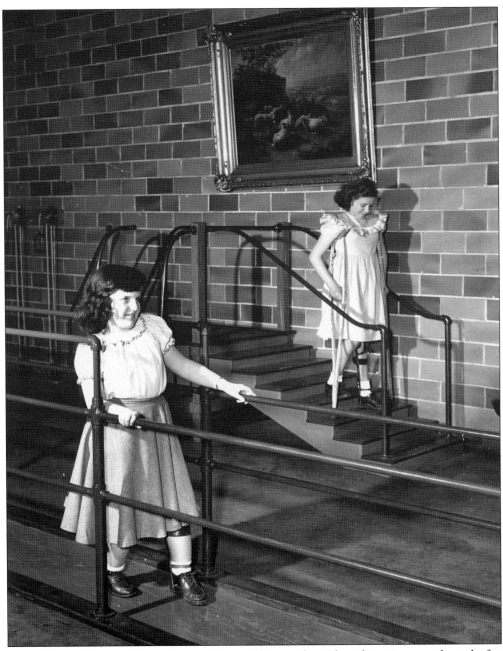

Ascending and descending stairs as well as walking with guide railings improved results for students with polio in this 1948 photograph. (Courtesy of George H. Davis Studio.)

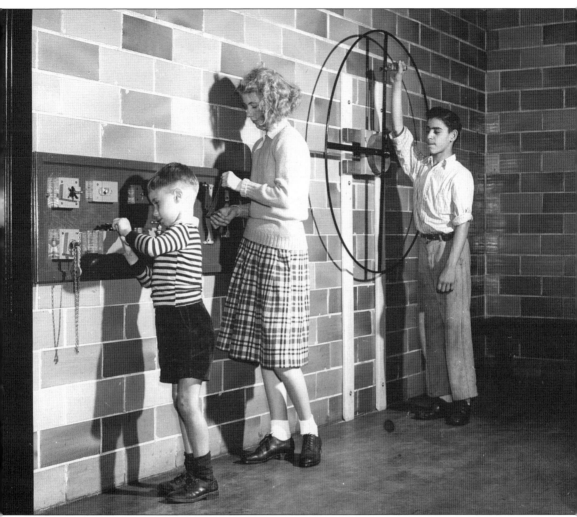

To strengthen muscles and increase manual dexterity, students used a variety of manipulative occupational and physical therapy devices such as this shoulder wheel in the 1950s. (Courtesy of George H. Davis Studio.)

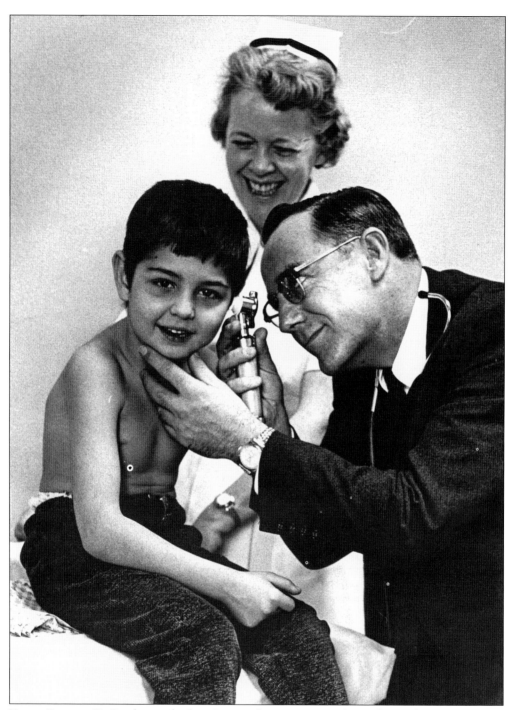

Nurse Frances McCarthy worked at Cotting for 19 years in the 1960s and 1970s; her son attended the school as well. She was appreciated by coworkers and students for her unfailing optimism and kindness. Here she assists Dr. John Spargo during a student medical exam.

Our students are handicapped by the following diseases:

Disease		Disease	
erebral Palsy	62	Brain Stem Dysfunction	1
pina Bifida	13	Arthritis	1
Iuscular Dystrophy	9	Asthma	1
olio	14	Arrested Hydrocephalus	2
irth Defects	8	Achondroplastic Dwarfism	1
ardiac Defects	5	Fibrous Dysplasia	2
egg Perthes	4	Meobius Syndrome	1
Iemiplegia	3	Neurofibromatosis	1
olyneuropathy	2	Pseudochondrodysplasia	1
araplegia	2	Louis Barr Syndrome	1
ongenital Paraplegia	2	Osteogenesis Imperfecta	1
rthrogryposis	2	Dyslexia	1
urn Deformity	1	Scoliosis	1
Iyopathy	1	Petit Mal Epilepsy	1
steochondritis	1	Slipped Epiphysis	1
Iypopituitary	1		

Stating "the control and treatment of infectious diseases has improved markedly over the past thirty years," Dr. Spargo's 1970 medical report reveals several important medical advances. He indicates the positive effect of the Salk polio vaccine, which became available in 1954 for the first time. He also mentions the German measles vaccine of 1963 as "significant" and the effect of the 1967 mumps vaccine as "helpful." By 1970 the number of children with cerebral palsy and spina bifida far outnumbered those with polio.

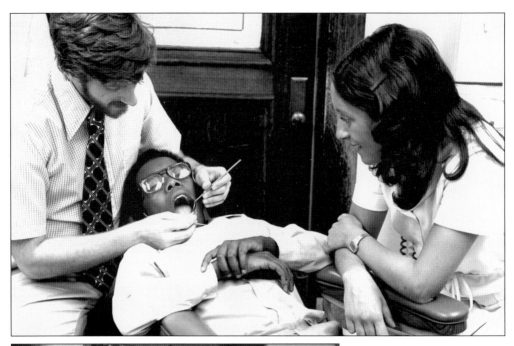

A dental clinic, affiliated with Tufts University School of Dental Medicine, and the Seamark Vision Clinic, affiliated with the New England College of Optometry, were installed to ensure that students have regular checkups. Each child can be seen twice annually at the dental clinic and once annually at the Seamark Vision Clinic. These services are very helpful for students and their families.

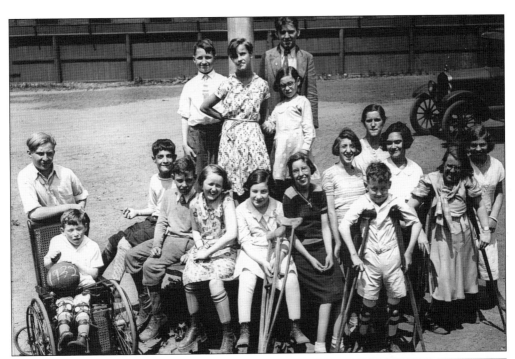

Supt. Vernon Brackett stated, "The proper training and development is as necessary, or perhaps more necessary, for the cripple than for the normal boy or girl. He must be trained to cooperate with others. He must be trained and given an opportunity for self-expression and to develop self-confidence, so that when he goes out in the world he can take his place by the side of others who are normal, and will not feel his handicap. The moral training of the school consists, not so much of formal instruction in morals, as it does of wise guidance and counsel and of gradually leading the child to enjoy and appreciate the best things of life. He must conform to somewhat rigid rules and be led to see that discipline is necessary for the benefit of the school as a whole."

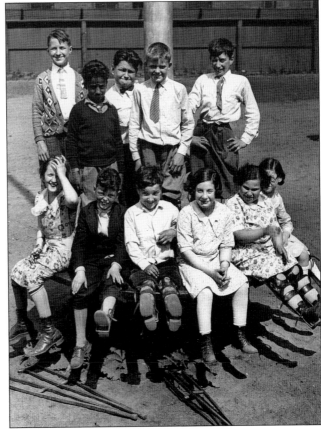

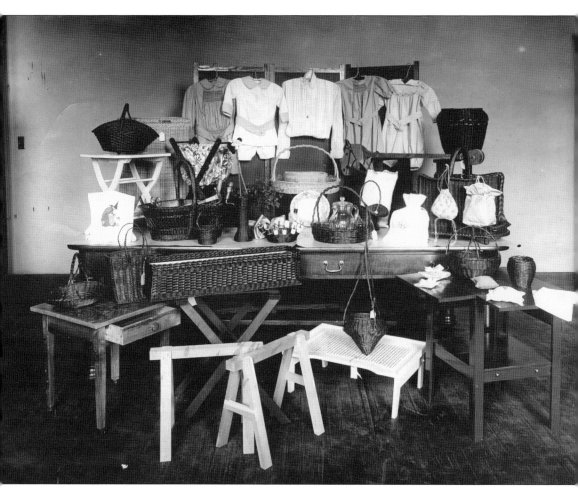

Helping students become more independent, a goal of the school's cofounders, continues today. Student-produced handicrafts led to employment opportunities upon graduation. In 1930, the school won the Powell Cup for Best American Exhibit in the International Exhibit of Handiwork of Cripples. In 1899, the cofounders wrote, "In addition to the three R's, printing, sloyd, dressmaking, millinery, and sewing have been taught, also elementary clay modeling. Massage has been given three times a week under Miss Ernst and her assistants." Sloyd was a system of woodworking education, which started in Finland in 1865 and was used in America in the early 20th century.

HAND WORK

FROM

The Industrial School for Crippled and Deformed Children

241 St. Botolph Street
Boston, Mass.

The cover and two pages from the school's "Hand Work" sales brochure are found at right and below.

NEEDLEWORK

BASKETS, TOYS

AND USEFUL ARTICLES

MADE BY PUPILS OF THE

Industrial School for Crippled and Deformed Children

A limited stock of the articles shown in this book is kept on hand, to which new designs are added each season. Orders for any of these and similar articles will be received and promptly filled from October to June. Orders for printing received through the year. Address 241 St. Botolph Street, Boston, Mass.

Infants' and children's wrappers
Price, $3.00 to $5.00

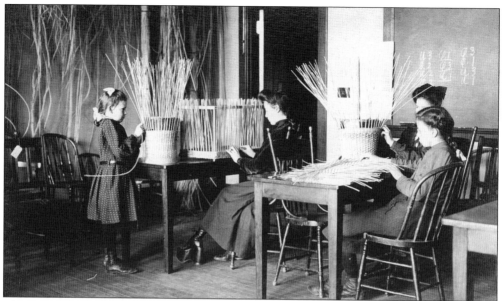

Above, girls weave baskets in the early 1900s, and below, boys and girls weave in the 1950s. In 1920, Supt. Charles Belknap was able to document successes of the school's founding principles and methods. "There were at the meeting of the Alumni Association more than eighty former pupils, the majority of whom had been able to secure no education beyond that afforded them by the School. Their handicaps were quite varied and under ordinary circumstances would excite sympathy, but it was shown by their quite evident prosperity and pride in their success, that they had reached the point where sympathy was neither needed nor desired. These successful alumni were proof of the soundness of the principles under which the charity was started, which were that the problem of the cripple is capable of solution; that the first step should be education; and that the extent to which success in the life of a cripple will be limited is not a matter of physical handicap but of mental ability and its development." (Below, courtesy of George M. Cushing Jr.)

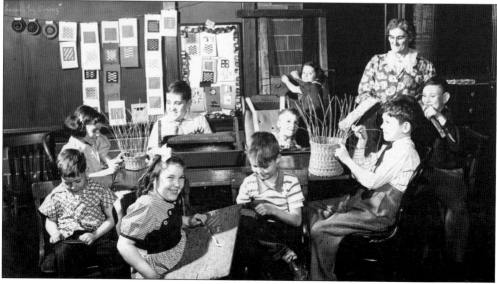

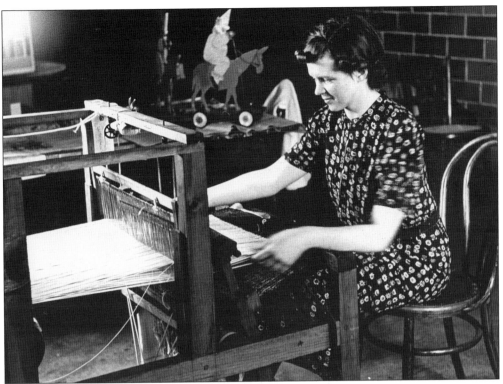

Students of all ages participated in weaving activities to increase manual dexterity. The above photograph is from the 1930s and the bottom from the 1950s. (Above, courtesy of Arthur Griffin.)

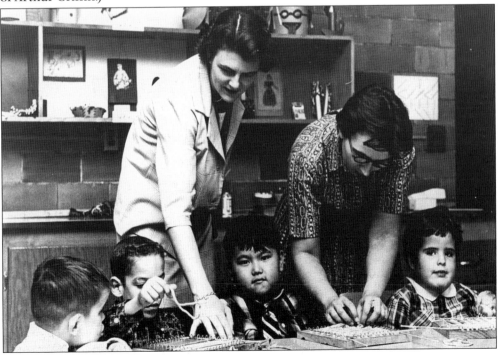

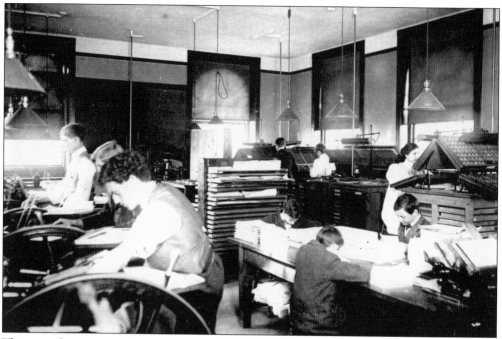

These students are setting type, printing, and folding finished products. The school took in orders from local businesses and the print business flourished. Each year the school printed its annual report, as well as those of customers.

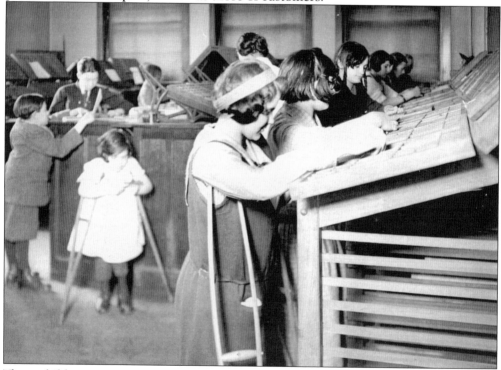

These children are setting type at the St. Botolph Street location in the 1920s. Note how younger as well as older children are involved in the process.

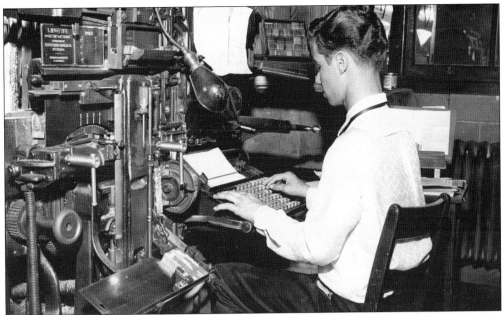

Above, John Chaves, who later attended Northeastern and Boston Universities, types into the linotype machine. Below, Bobby Woodson, who joined the *Boston Record American* immediately upon graduation, prints materials while his instructor inks a machine. Both photographs were taken in the 1950s.

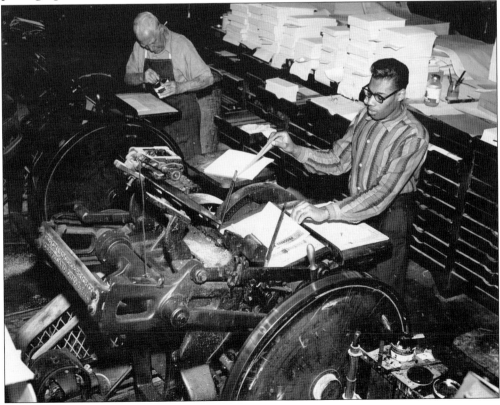

Teacher Beth Johansen teaches proofreading skills to two of her students. Paul Kelly, far right, joined a daily newspaper in Norwood, Massachusetts, following his graduation.

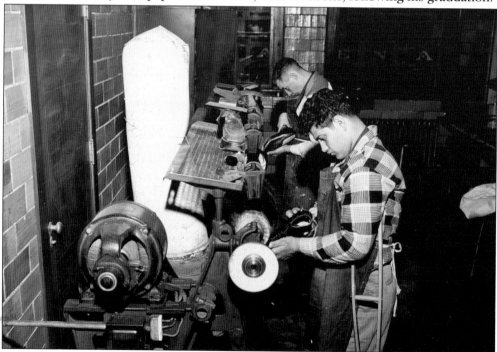

These students buff shoes on cobbling equipment in the 1950s. Students repaired orthopedic shoes for fellow students as well as shoes of outside customers. According to former superintendent William Carmichael, John Maloof, front, a native of Cyprus, arrived at the school with crutches made of tree limbs. Raytheon employed Maloof upon graduation.

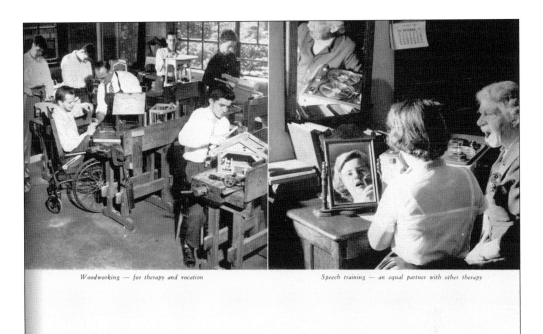

Woodworking — for therapy and vocation *Speech training — an equal partner with other therapy*

WORK, PLAY AND TRAINING - ALWAYS TOWARD THE FUTURE

Play is learning — learning to live happily *Office training will aid many toward self-support*

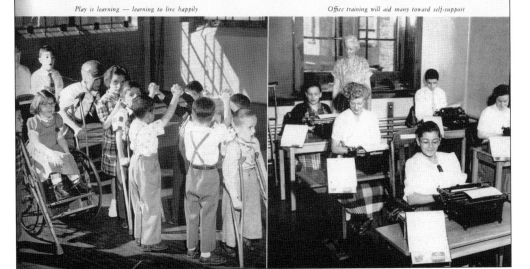

The 1953 annual report contained four photographs of therapies: woodworking, speech training (now called communication therapy), play, and office training (now called work skills), indicating the school's emphasis on maximizing each child's goal of independence, self-reliance, and self-support.

The INDUSTRIAL SCHOOL Fo
Crippled and Deformed Childrer

The school's cooking class is featured in this 1940s advertisement above. "The intangibles, particularly, are a very real part of the school: the opportunity for overprotected children to reach for independence and self reliance, to be guided toward maturity and—something few of us can master—the understanding of how to live to the fullest." (Courtesy of Alice Y. Colon, Boston Bar Journal.)

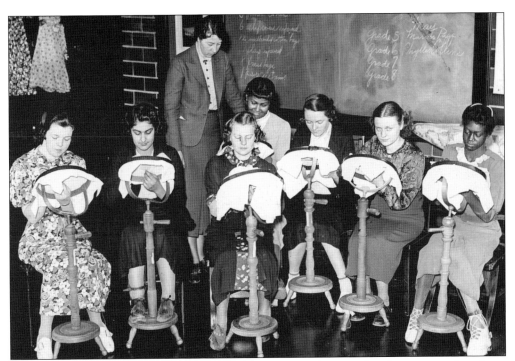

Sewing and needlework augmented the girls' curriculum, and orders were taken from outside the school. Once students became proficient, they were paid for their work. These students are embroidering in the 1930s, continuing a long tradition of handiwork, which increased fine motor skills. In the 1950s photograph, students take care to match the plaid as they place pattern pieces.

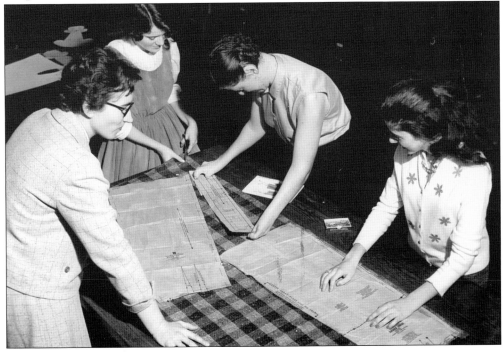

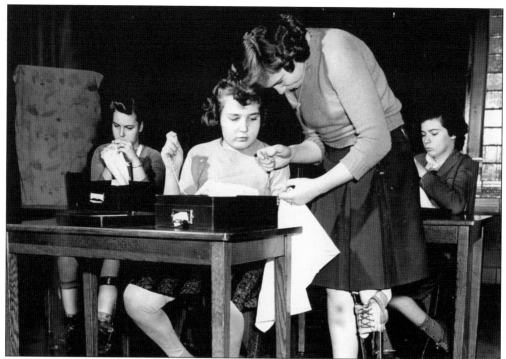

Originally sewing was taught as a vocational class, with an emphasis on fine needlework and embroidery. In the 1940s photograph above, girls practice sewing buttonholes on garments they might actually wear or sell. The 1970s home economics teacher below adjusts the gathers on a student's sundress as fellow classmates look on with admiration. This style was popular at the time and involved gathering several rows of elastic to create the tucks in the bodice.

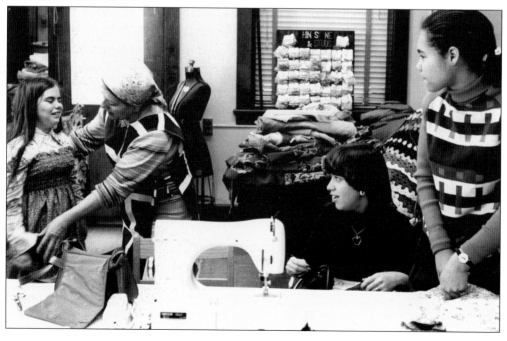

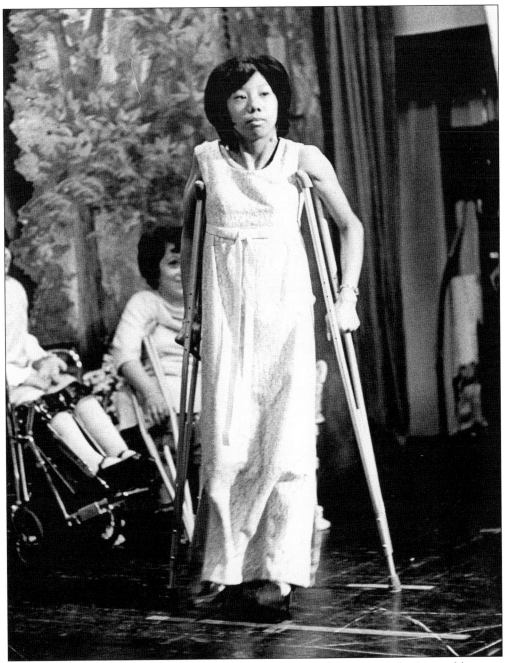

Senior Nancy Soo sewed this dress, which she wore to the prom and, pictured here, at graduation, on June 1, 1967. Nancy later worked as a clerk/typist in the insurance industry in Boston. (Copyright, Globe Newspaper Company, republished with permission.)

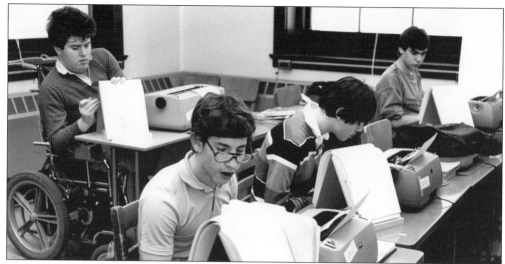

Teachers and therapists were able to help students improve educational outcomes, especially communication skills, with each generation of typewriters and computers. In the above photograph, students improve their typing skills using IBM Selectric Typewriters. In 1979, Cotting began working with LOGO, a computer-based learning system for people with disabilities developed at Massachusetts Institute of Technology (MIT), as seen in the photograph below. Former superintendent William Carmichael said of the student pictured below, "I had Michael for nine years as a non-verbal student. I knew he was bright but unable to demonstrate this due to the severity of his cerebral palsy." That changed when Dr. Sylvia Weir of the Artificial Intelligence Department at MIT and two of her assistants concentrated on his using a keyboard and umbilical cord attached to a multiwheeled domed device that he controlled. Michael was featured on a television program called *That's Incredible!* Michael later attended the University of Massachusetts in Boston. His success opened eyes to the potential of computer science as a teaching aid as well as a viable career opportunity for physically disabled students.

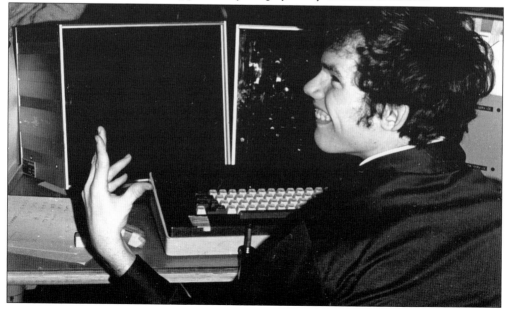

Two

THOSE WHO
SERVED THE SCHOOL

CHARTER

Commonwealth of Massachusetts

BE IT KNOWN That whereas E. Pierson Beebe, Joseph S. Bigelow, E. H. Bradford, Elliott G. Brackett, Augustus Thorndike, E. H. Clement, and George B. Upham have associated themselves with the intention of forming a corporation under the name of THE INDUSTRIAL SCHOOL FOR CRIPPLED AND DEFORMED CHILDREN, for the purpose of promoting the education and special training of crippled and deformed children, and have complied with the provisions of the Statutes of this Commonwealth in such case made and provided, as appears from the certificate of the President, Treasurer, Secretary and Trustees of said Corporation, duly approved by the Commissioner of Corporations, and recorded in this office:

Now, THEREFORE, I, William M. Olin, Secretary of the Commonwealth of Massachusetts, do hereby certify that said E. Pierson Beebe, Joseph S. Bigelow, E. H. Bradford, Elliott G. Brackett, Augustus Thorndike, E. H. Clement, and George B. Upham, their associates and successors are legally organized and established as and are hereby made an existing corporation under the name of The Industrial School for Crippled and Deformed Children, with the powers, rights, and privileges, and subject to the limitations, duties, and restrictions which by law appertain thereto.

WITNESS my official signature hereunto subscribed, and the seal of the Commonwealth of Massachusetts hereunto affixed this twenty-seventh day of March in the year of our Lord one thousand eight hundred and ninety-four.

[SEAL.]

WM. M. OLIN,
Secretary of the Commonwealth.

The Commonwealth of Massachusetts granted a charter to the school on March 27, 1894. The first officers of the Industrial School for Crippled and Deformed Children were Augustus Hemenway, president; E. Pierson Beebe, treasurer; and Joseph Bigelow, secretary.

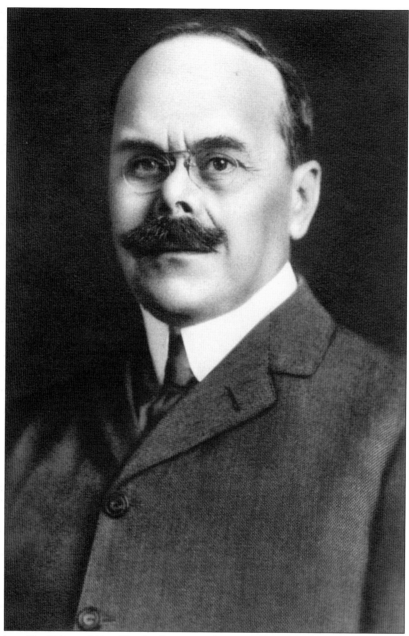

Cofounders Dr. Edward Bradford, above, and Dr. Augustus Thorndike, opposite page, found that a large number of their outpatients at Children's Hospital who had "paralyzing and crippling afflictions . . . were growing up in ignorance." Dr. Bradford visited European schools for children with disabilities in Norway, Germany, Sweden, and Denmark to research the concept before returning to share information with Dr. Thorndike. Dr. Bradford wrote, "There was difficulty in starting, but after we started the idea caught on. There has never been any difficulty in securing money; it has always been given, never solicited." Typically modest, each doctor gave the other full credit for founding the school. Dr. Bradford served as a trustee for 34 years until his death in 1926.

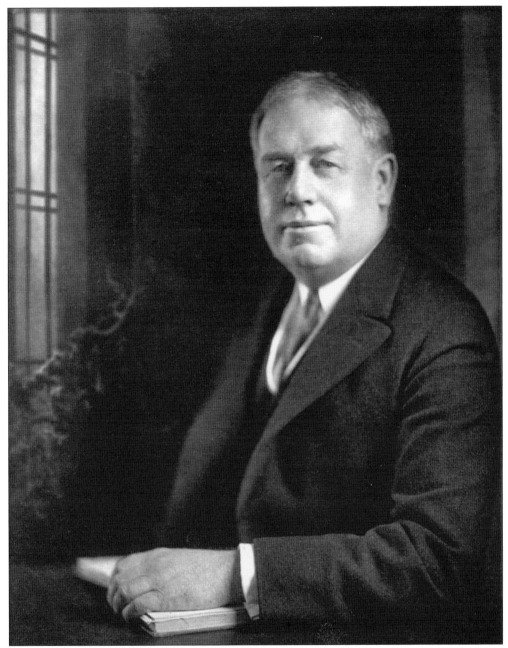

When Dr. Thorndike died in 1940, after 48 years of dedicated service to the school, board president Charles H. Taylor Jr. wrote of this visionary leader, "He was particularly fitted for his aid to the School. Not only did he have medical and surgical knowledge and experience as a leader in his profession, but his kindly nature and deep understanding endeared him to the staff and trustees of the School, and also to every child with whom he came in contact." Drs. Bradford and Thorndike each had a son who entered the medical profession and served as a trustee. Many descendants of both founders have served and continue to serve the school.

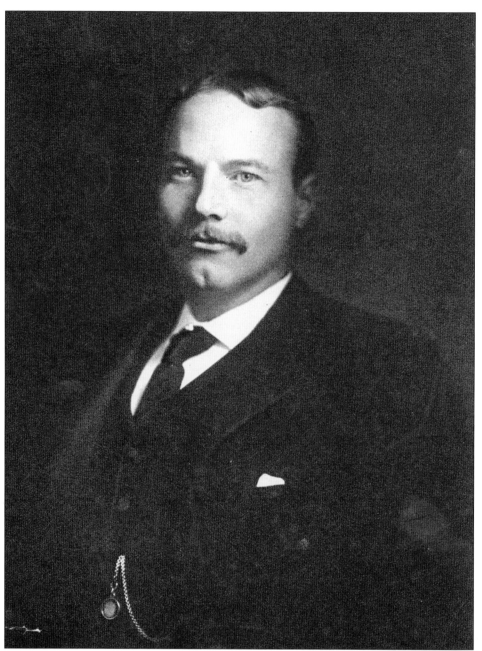

Challenged by his own physical disabilities, Francis Joy Cotting was elected to the board in 1897 and served as president until his death in 1914. Among his many accomplishments, he inaugurated the school's endowment, spearheaded the first long-range plan, helped secure funding for the new building and playground, and started traditions of Thanksgiving and Christmas celebrations for the students. A plaque in the lobby of the St. Botolph Street school building read, "He found it a struggling experiment. He left it a valued institution." Francis Cotting was also a sports fan. His automobile was one of the first fitted with hand controls, which permitted him to drive onto the football field at Harvard to watch practices and games.

Charles E. Cotting, the nephew of Francis Joy Cotting, cultivated many private donors to the school to ensure that the endowment continued to grow. His careful financial management and sound fiscal practices during the Depression and the years following kept the school stable. Between 1941 and 1981, the endowment grew more than 10 times its value under his oversight. Charles was a trustee from 1922 to 1984 and the treasurer from 1927 until 1981. Supt. William Carmichael stated, "He was the 'backbone' of the trustees, who deferred to his judgment." (Courtesy of Fabian Bachrach.)

Boston ... 19

MR. CHARLES E. COTTING, *Treasurer*,
 241 St. Botolph St.,
 Boston, Mass.

Dear Sir:
 Enclosed please find

.. Dollars
for THE INDUSTRIAL SCHOOL for CRIPPLED and DEFORMED CHILDREN
 Yours truly,

NAME ...

ADDRESS ..

 ...

 In circulating the Annual Report of The Industrial School for Crippled and Deformed Children, the Trustees would remind its friends that, while the financial condition of the School is sound and satisfactory, the cost of conducting it exceeds by a substantial amount its fixed revenue, with the budget figured carefully in advance on the most conservative possible basis. The maintenance and expansion of the School in its field are dependent on outside support now as they have been in the past, and contributions are earnestly asked from present and new believers in the work the value of which is being demonstrated clearly by the graduates.

 Subscriptions are received by

 CHARLES E. COTTING, *Treasurer*,
 241 St. Botolph Street,
 Boston, Mass.

Charles Cotting clearly understood that if Drs. Edward Bradford and Augustus Thorndike's "experiment" was to thrive, fund-raising and prudent financial management were needed. His long-term plans included asking donors to remember the school in their wills. The above circular with a return envelope to Charles Cotting's attention was found in each year's annual report.

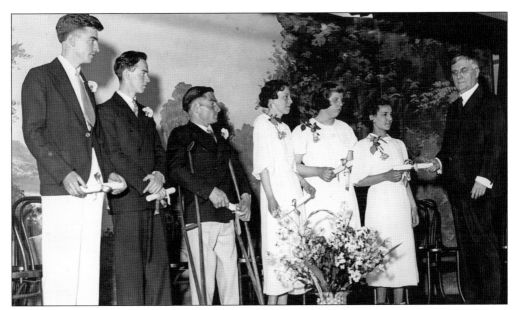

Three generations of the *Boston Globe*'s Taylor family, beginning with Charles H. Taylor Sr., led the board. Already a trustee for 34 years when he was elected president in 1933, Taylor served until his death in 1941. He raised funds for improvements to the original building, for the 1926 addition, and for vehicles to transport a greater number of students. Every year he arrived at Christmas parties, his pockets bulging with silver dollars, one for each child.

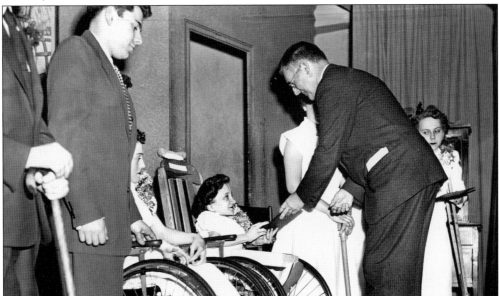

Charles H. Taylor Jr. was elected board president in 1941. Under his leadership, the school expanded services to include students from more than 50 communities. He also increased vocational training to broaden postgraduation employment opportunities for students. At the end of his 34-year term, he was awarded the school's Distinguished Service Award. Above, he is presenting Lorraine Burke, class of 1953, her diploma. Nine years later, Burke was honored as Outstanding Disabled Woman of the Year.

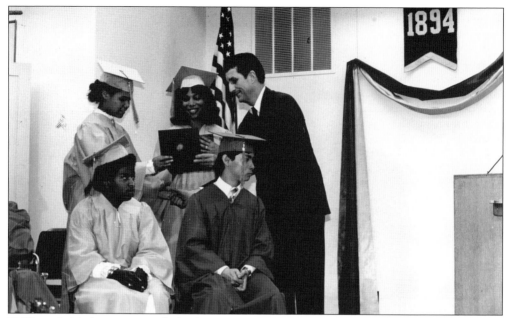

William O. Taylor, cousin of Charles H. Taylor Jr., chaired the board from 1973 to 1986. He advocated moving the school from Boston to Lexington in order to give the students a more rural setting for therapies and gym as well as a more geographically central location. He also upgraded the wages, salary scale, and the benefits for faculty, keeping pace with the current workplace. Under his leadership the school's name was changed to Cotting School.

Raymond Killian Jr. designed and taught a successful science program and coached basketball at the school. Later, as the founder and chairman of Investment Technology Group, Inc., Killian and Richard McDonald, another member of the investment community, started a fund-raising event with members of the Boston investment community that, since 1980, has raised over $4 million for Cotting School. Killian was Cotting board chairman from 1986 to 2000. The school's gymnasium is named in his honor, the playground in honor of his parents, and the Killian Family Graduation Award is given each year.

Anne Phillips Ogilby succeeded Ray Killian Jr. and is currently the board chair. During her tenure, Cotting School opened the Mary Perry Building and HOPEhouse, a residential program for eight young adults. In addition, Ogilby oversaw the search for the current school president in 2004 and the development of the Cotting School Strategic Plan in 2005. She is a partner at the law firm of Ropes and Gray in Boston.

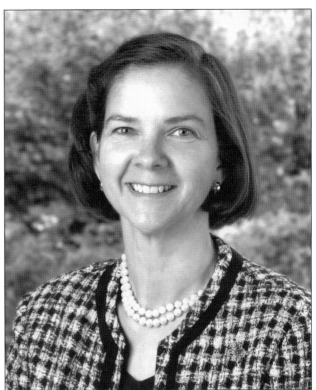

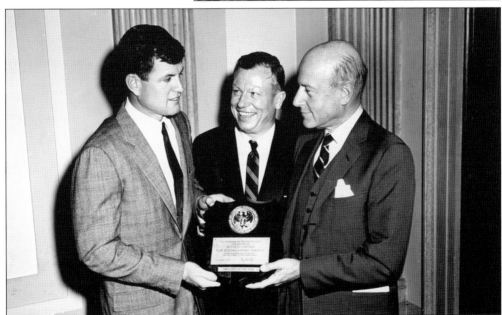

Raytheon president Charles F. Adams was a trustee from 1937 to 1991. In a Capitol Hill ceremony, Sen. Edward M. Kennedy (left) presents a Presidential Citation recognizing Raytheon as the leading employer of individuals with disabilities. Harold Russell, chairman of the President's Committee on Employment of the Handicapped, is at center. Adams was unwavering in his support for children and adults with disabilities.

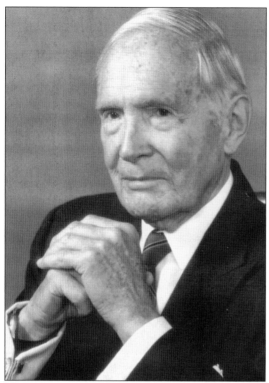

Francis H. "Hooks" Burr, a partner at the law firm of Ropes and Gray, served as a trustee and trustee emeritus from 1946 until his death in 2005. Superintendents Vernon Brackett, William Carmichael, and Carl Mores sought his trusted counsel. Thanks to his wife, Lucy Burr, a donation from American Airlines in his memory allowed the school to begin outreach services to children with severe special needs in Haiti.

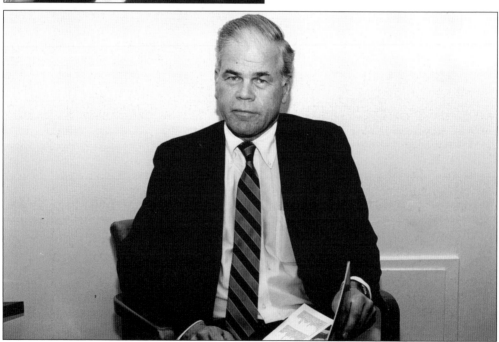

John L. Thorndike is the grandson of the school's founder, Augustus Thorndike, and a former director of Fiduciary Trust Company. Since 1983 he has been a wise and trusted financial advisor, serving the school as trustee, treasurer, and treasurer emeritus. He currently serves on the school's Finance and Investment Committee.

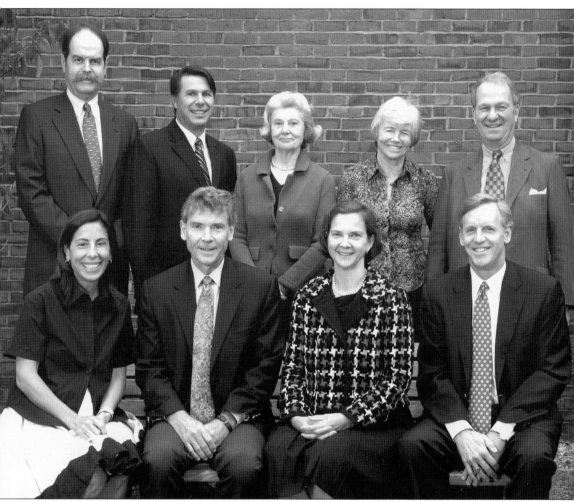

The wise stewardship and support for the school started by its founders continues with the current board of trustees. From left to right are (first row) Lynda Kabbash, John Beach, Anne Ogilby, and Stuart Randle; (second row) D. Eliot Klein, David Manzo, Joan Thorndike, Elise Wallace, and David Lee. Missing from the photograph are David Cushing, John Chaves, Charles Haydock, Raymond Killian, and Virginia Nicholas. Board senior vice president David Lee is the longest serving member, beginning in 1970. Two trustees also served on the Friends Committee (formerly the Ladies Committee): Virginia Nicholas and Joan Thorndike. In addition, Wallace and Thorndike began volunteering at the school in 1968.

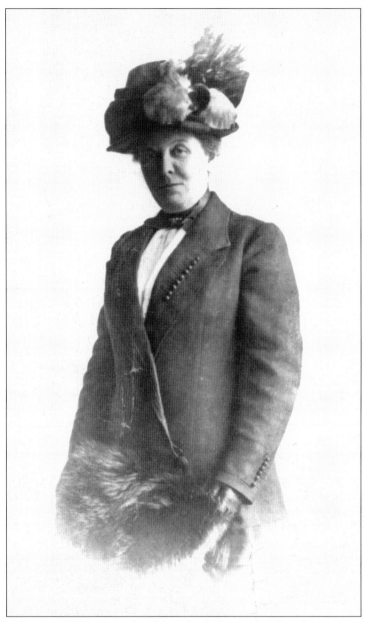

Since its founding in 1893, the school has had six superintendents (currently called presidents) beginning with Mary Perry, photographed above. Perry served the school from 1894 to 1919, beginning as a volunteer teacher when the school opened with seven pupils on Chambers Street. She was fully committed to the experimental school of Drs. Augustus Thorndike and Edward Bradford. In 1904, the first year in the new building, the school's Industrial Committee wrote of her, "The patience and tact of Miss Perry and her assistants must be praised for bringing out of confusion, which necessarily existed at first, the order and helpful spirit which now permeates the whole beautiful building." In 1919, she resigned, asking for "relief and a rest since her responsibilities and duties have, at last, become so heavy." After resigning as superintendent, Mary Perry remained active in the alumni association and later taught wounded World War I veterans.

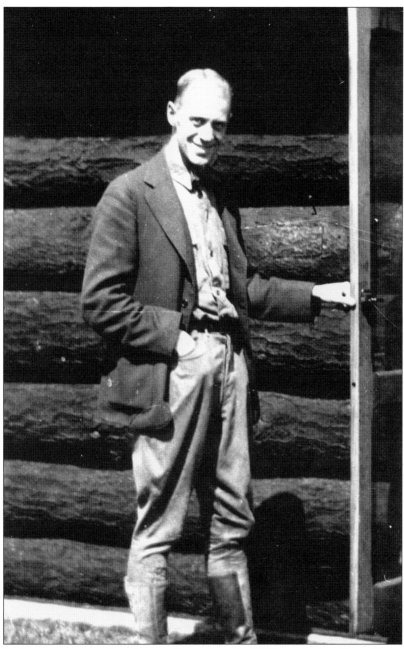

Charles Belknap was appointed superintendent in 1919, replacing Mary Perry. He was committed to offering a varied and comprehensive academic and vocational curriculum. Concerned about the postgraduation opportunities of former students, he met with 80 of them in 1920. In 1921, he admitted the first out-of-state students. He also suggested to the trustees that the school change its name from the Industrial School for Crippled and Deformed Children to something "shorter and less descriptive." When he died in March 1923, the trustees noted, "his noble efficiency and the manner in which, in a comparatively short time, he organized the School's curriculum on a sound and systematic basis . . . with valuable improvements and innovations."

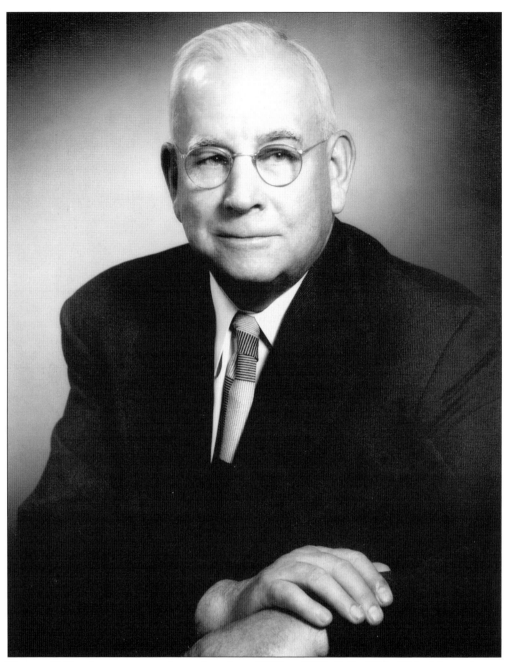

Vernon K. Brackett was superintendent from 1923 to 1955. Called "Mr. B" by his students, he oversaw the 1926 expansion of the school building. With more than double the space, the school expanded the industrial departments and added assembly, play, medical, and dining rooms as well as a modern kitchen. The school's centennial history states, "During his time as superintendent and especially in the difficult years when expenses exceeded receipts, one of Vernon Brackett's most enduring, quiet strengths was the long-lasting fatherly relationships he formed with a vast variety of students and alumni."

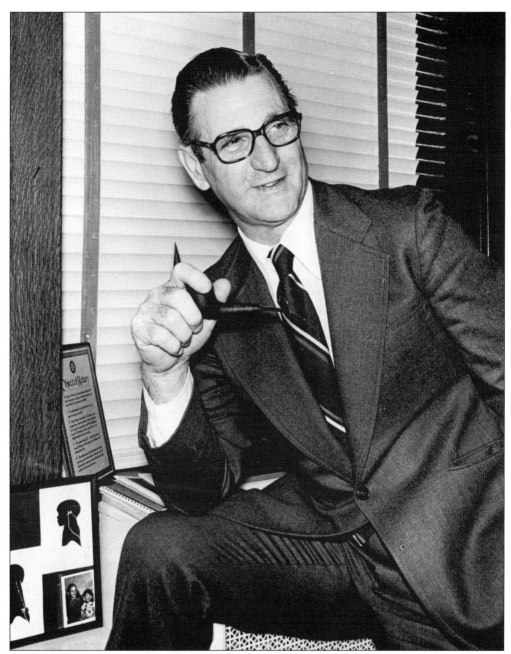

"After he came, we were like one big family, we pulled together," former high school principal Lucy Dattman said of William Carmichael. Named superintendent at 33 years of age, Carmichael led the school from 1955 to 1984. His tenure was a period of change. He updated the facility, removing 50-year-old fixtures, adding the Augustus Thorndike Memorial Music Room, and setting the school on a path to meet the changing needs of the students. Beginning in 1954, with the introduction of the Salk polio vaccine, the school's population shifted dramatically. During his tenure, Carmichael stressed the education of the whole child through a strength-based curriculum. He initiated physical education, electronics, science, math, and independent living programs.

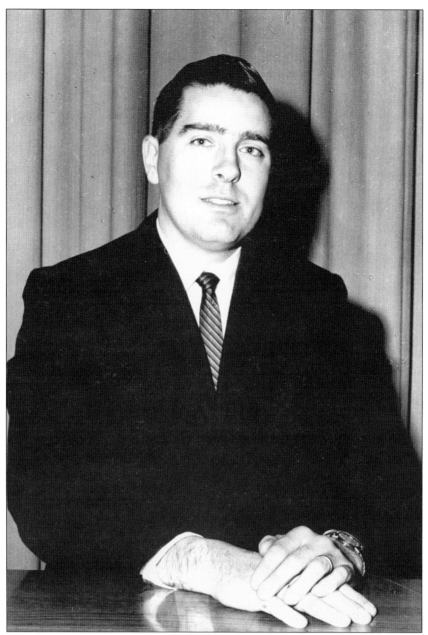

Carl Mores understood that if Cotting School, America's founding institution in the field of special education, was to continue as a pacesetter, it needed to relocate the 1904 facility in Boston to a more spacious, geographically central, and modern facility. The relocation of the campus to Lexington, Massachusetts, was a defining moment in the school's history. The new facility, which was completed on time and on budget, allowed for expanded medical, occupational, physical, and communication therapy services, as well as outdoor education activities to meet the increasingly complex medical and educational needs of the students. In addition, Mores opened HOPEhouse, the Intensive Services Program, and Project Bridges. He served from 1984 to 2004 and was succeeded by David Manzo.

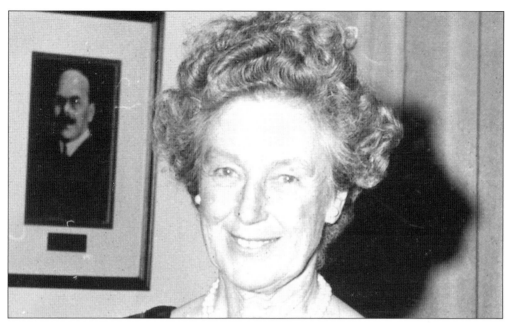

For nearly all of the school's 115 years, a group of volunteer women enhanced services for students, raised funds for new programs and building renovations, and gave tours. Photographs of three of the hundreds of Ladies Committee members follow. For 21 years, Sarah Cotting, wife of Charles E. Cotting, chaired the committee. Under her supervision, the Ladies Committee renovated eight rooms at the school. Elected vice president of the board in 1974, she died at age 99 in 1992.

Gertrude Adamowski volunteered as a member of the Ladies Committee for 40 years, beginning in 1910. Long the committee's chair, she was elected as the first female vice president of the board in 1942. In 1950, she resigned from both positions for health reasons and died in July 1951. Student Harold Remmes remembered her as "swift, flamboyant . . . she would sweep through the School, disrupting classes . . . the children loved her."

Dr. Augustus Thorndike's granddaughter, Sarah Thorndike Haydock, a member of the Ladies Committee from 1967 to 2003, also served as its chair. Sally raised money to support summer camping experiences for the students. She led by example, encouraging ladies to volunteer their time in school. Elected to the board in 1983, she served for 20 years, continuing a family tradition, as does her son Charles, who is currently treasurer. Sally's first cousin, Jackie Payne, served on the Ladies Committee from 1966 until her death in 2001. A dedicated volunteer, Jackie was also the niece of Sarah Winslow Cotting, wife of Charles Cotting, and granddaughter of the school's founder, Dr. Augustus Thorndike.

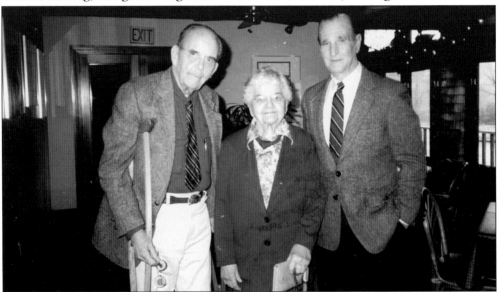

Dr. Charles H. Bradford, pictured at left with his sister Elizabeth and William Carmichael, is the son of Cotting's cofounder. A noted surgeon and author, he financed the James Warren Sever Room in Boston, as well as graduation awards honoring his father and Charles E. Cotting. Elizabeth Bradford, who remained involved with the school until her death in 2007 at 101, was an innovator in teaching students with learning disabilities.

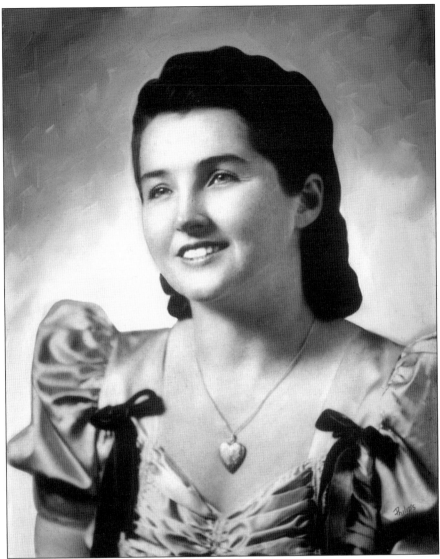

The following five photographs are a small sampling of the extraordinary students who have attended the school and continued to make a significant contribution after graduation. Dorothy Pace, pictured above, made application to the school from her home in Portsmouth, New Hampshire. The daughter of a farmer, she moved to Roxbury and took a streetcar to the school where she focused on the vocational skills of sewing and printing. After her graduation from junior high school, she worked in a printing office in Concord, New Hampshire, from 1925 until 1929. She returned to the school for instruction in linen embroidery and subsequently opened a gift shop in Portsmouth. When, in 1937, Pace needed surgery, members of the Ladies Committee, led by Gertrude Adamowski, oversaw her shop during Pace's hospitalization and assisted in paying her medical costs. Soon after returning to work, Pace opened an answering service for doctors. Later, her assembly and reclamation factory, Pace Industrial Corporation, hired more than 50 disabled workers. Her work led to the founding of the Portsmouth Rehabilitation Center. Her generous bequest created the Pace Assistive Technology Assessment Center at Cotting School in 2005. (Courtesy of Brandt and Sandra Pace.)

Norman Ingram, a member of the class of 1931, taught woodworking and was a guidance counselor for 32 years. Flanked by two high school students, Ingram here provides instruction for developing chrome-finished go-carts, which will then be used at Children's Hospital in Boston to move young patients.

Harold Remmes attended the school from 1936 to 1948 and later served as president of the alumni association and as a trustee. He organized the Massachusetts Council of Organizations for the Handicapped, leading the cause to improve accessibility in school buildings. A quote from the school's centennial history captured his determination, "A motivated person can cope with a hostile world. The most important thing the School did for me was to teach me to be self-reliant and self-supporting, to claw my way up with fingernails if necessary." (Courtesy of Jet Photographers.)

John Chaves has made a lifelong commitment to the school beginning as a student from 1947 to 1959. He graduated from Boston University and earned his doctorate at Northeastern University. In exchange for his dissertation, NASA paid his educational expenses. Chaves has held professorships at the University of Southern Illinois and Southern University of New York (SUNY) Stony Brook. For many years he was the president of the school's alumni association, and since 1990, he has served as a trustee of the school.

After graduating in 1960, Patricia Dabrowney served as receptionist and executive secretary at the school. For many years she led the alumni association. On the occasion of her retirement in 2005, the board of trustees recognized her 45 years of service to this school, stating, "As an outstanding executive secretary, her wit, wisdom, hard work and values helped guide this school during a critical period in its history. In addition, as a former student of the school, Pat exemplified the spirit and dedication of all Cotting students."

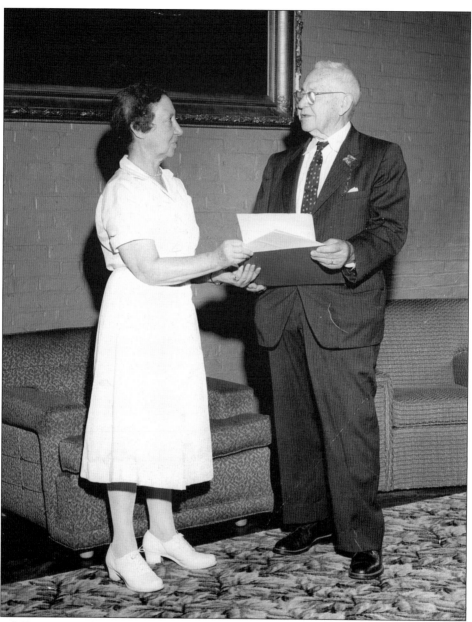

The following six photographs honor staff members who served with distinction for more than 35 years. Dr. James Warren Sever started working at Cotting School in 1912, when cofounder Dr. Edward Bradford resigned as medical advisor; he stayed for 52 years. In 1930, the trustees' report commented on the hiring of Dr. Sever: "His work has been most satisfactory and resulted in more careful case records, better checking up and following up of absentee pupils who are ill, improved cases and conditions or orthopedic appliances and splints, and better medical oversight of the muscle training exercises for paralytics. The trustees appreciate the value of this service and wish to express formal gratification." He is shown here with nurse Mildred Wiggin, who left Cotting to work as an ambulance driver in World War I and then returned to Cotting after the war. She worked at the school for 43 years, until 1964.

Lucy Sim Dattman was a gifted teacher and high school principal at the school from 1927 to 1984. For remarkable educational leadership, she was awarded the Cotting School's Distinguished Service Award. She often tackled challenging problems for students whose disabilities had come later in life due to an accident or recent diagnosis.

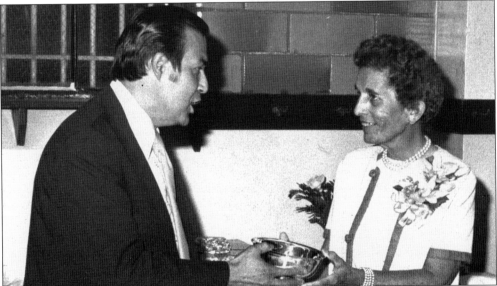

Above, Louise Marr receives a Revere Bowl from one of her former students, Arthur Downing, on the occasion of her retirement. Marr came to the school after teaching in a one-room schoolhouse in Maine. She served the school as a teacher from 1935 to 1976. Downing attended the school for eight years. He graduated from Northeastern University and became a design engineer at Raytheon. He has served on the Cotting School Medical and Senior Advisory Council. About his experience at the school, Downing stated, "I was four when I developed polio. At the School I learned to accept my handicap as something not unconquerable. The true spirit of my first eight years at St. Botolph Street gave me the foundation on which to build."

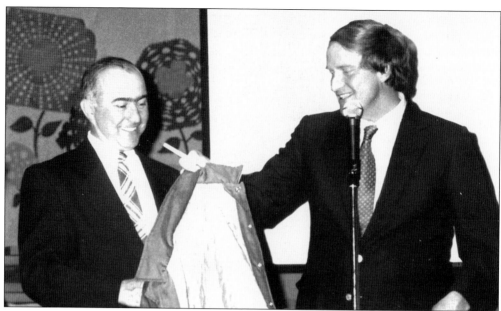

James Tanner has been a student, teacher, and basketball coach and is currently the director of prevocational services. Pictured at right, Tanner and former headmaster Michael Talbot prepare to award a letter jacket to one of Tanner's players. Tanner attended the school from 1963 to 1970, returning to the school as a teacher in 1975. Michael Talbot served the school for 37 years as a teacher and administrator. During the construction of the Lexington campus, Talbot held key leadership positions that led to a smooth transition of Cotting School from a Boston-based to a regionally based school.

Noreen Murphy was an educational innovator. There were no limits to what students could achieve in the field of music in her classes. Known for her skill in staging musicals and plays and for discovering hidden talents in Cotting students, Murphy taught music and drama for 40 years, beginning in 1965 and retiring in 2005.

Rose Zunke taught Cotting students computer and math skills for 37 years, beginning in 1970 until her death in 2007. Zunke influenced generations of Cotting children. Kindness and humor, coupled with practicality and independence, made her a favorite with students and staff. Zunke's "can do" attitude inspired many children and staff with whom she worked.

The following photographs in this chapter recognized individuals and organizations who supported the school financially. From 1975 to 2003, Frank Scalli, the leader of a group of New England scuba divers, raised funds to build and equip the Seamark Vision Clinic for the students. Former superintendent William Carmichael called him "the School's best friend and #1 promoter." His annual fund-raising events at the New England Aquarium featured such notables as Jacques Cousteau, Jean-Michel Cousteau, and Robert Ballard.

the handicapped child CAN receive . . .

A 12-Year Academic Program—Transportation—Vocational Training—Medical and Dental Care—Speech and Physical Therapy—Social Development—Noon Meal—Testing—Recreation—Summer Camping

**Without cost
In a private day school**

President: Charles H. Taylor

Treasurer: Charles E. Cotting
10 Post Office Square
Boston

Superintendent: Wm. J. Carmichael

Supported Solely by Legacies, Bequests and Contributions.

In addition to Frank Scalli's Seamark group, numerous organizations have supported the school, including the Elks Club, Aid to Muscular Disease Research, the United Order of True Sisters, the Boy Scouts and Cub Scouts, Freemasonry, and of course, the Cotting School's Ladies Committee and alumni association. The above advertisement appeared in the *Jewish Advocate* around 1965.

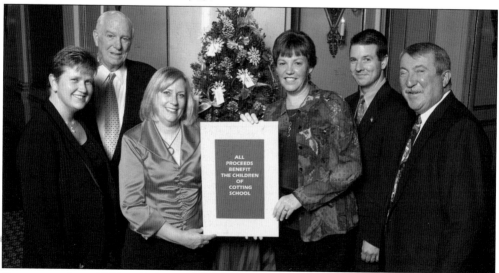

Every year since 1980, a dedicated group of investment professionals has hosted a party to support the school, accumulating over $4 million. From left to right, the 2006 Boston Investment Community's party committee members are Jeanne Austin, Ray Killian, Susan Nelson, Marybeth Forbes, Tom Quinn, and Richard McDonald. Not pictured are Edward Doyle, Frank Driscoll, David Hennessey, and Frank Murphy.

Three

FROM BOSTON TO LEXINGTON, THE BUILDING OF A SCHOOL

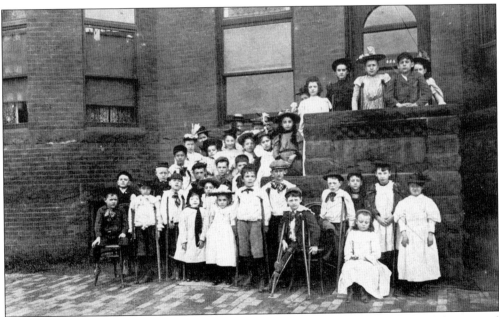

In June 1894, the Reverend Reuben Kidner of the Mission of St. Andrew offered the unused basement of his church at 38 Chambers Street in Boston, rent free, to the founders of Cotting School. The school opened its doors on October 1, 1894. In need of additional space during its third year, the school moved to 6 Turner Street in the Back Bay section of Boston. There, 26 students were educated in two small schoolrooms. One year later, the school moved to 424 Newbury Street, increasing to 44 students in the grammar and primary rooms and 11 pupils who attended the industrial classes. In the above photograph, students gather in front of the Newbury Street site.

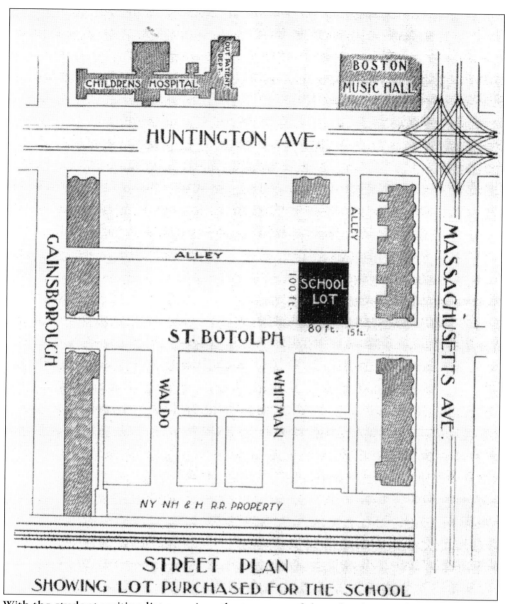

STREET PLAN

SHOWING LOT PURCHASED FOR THE SCHOOL

With the student waiting list growing, the trustees of the school appealed to the public "for funds with which to procure land and create a schoolhouse." In January 1900, a committee of the board was instructed to negotiate the purchase of a lot of land on St. Botolph Street in Boston at a price not to exceed $2.50 per square foot. From 1892 to 1913, Children's Hospital Boston was located on Huntington Avenue, a short walk from the school. The proximity allowed the school's cofounders and Children's Hospital doctors Augustus Thorndike and Edward Bradford easy access to the new school. The affiliation between Cotting School and Children's Hospital Boston continues today.

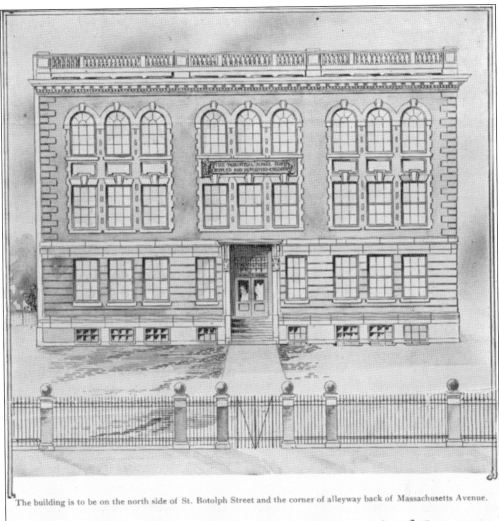

The building is to be on the north side of St. Botolph Street and the corner of alleyway back of Massachusetts Avenue.

Some facts about the work and the need of $50,000 to secure our Building.

The following quote was found in this 1903 fund-raising pamphlet: "Some facts about the work and the need for $50,000 to secure our Building. Almost as many deserving children as are now undergoing instruction in the Industrial School for Crippled and Deformed Children are excluded from its benefits from lack of room facilities. Three years ago the maximum limit of the present quarters at 424 Newbury Street was reached and two years ago 37 crippled children were on the waiting list. That list has increased and the piteous helplessness of these little 'outsiders' cries an entreaty to the generous, the charitable, the philanthropic, to give to swell the building fund. At least $50,000 more is necessary before the trustees can seriously consider the placing of a contract for the new building. With the land for three years and free of debt in hand, and $100,000 subscribed toward the new building, relief for the unfortunate children shut out from instruction should not be long delayed."

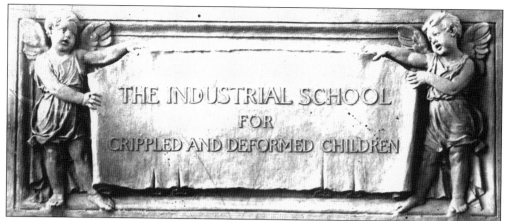

The above plaster casting for the Industrial School for Crippled and Deformed Children could be found on the exterior of Cotting School's building between the second and third floors. Its likeness also appeared on the school's early annual reports. The name of the school reflects a part of the history of the categorization of individuals with disabilities in the United States. Subsequent name changes continued to reflect evolving attitudes as the name transitioned to the Industrial School for Crippled Children (1948), to Cotting School for Handicapped Children (1974), to Cotting School (1986). The original name belies the progressive mission of the school and its founders.

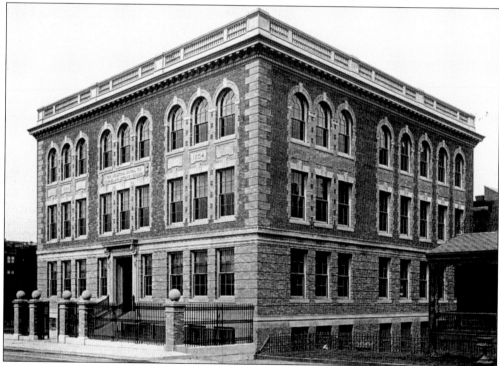

To prospective donors the trustees pleaded, "The tenth anniversary will occur in October, 1904. What a splendid contribution to the celebration of that event would be the gathering in a newly completed school building. . . . Small sums of money as well as large will be gratefully received in aid of this institution, which draws no line in regards to color, nationality or religion."

CRIPPLED CHILDREN ASK FOR LARGER QUARTERS

Fair in Aid of Building Fund of Industrial School for Crippled and Deformed Children Will be Held Wednesday, Nov 22

According to the November 5, 1922, *Boston Globe,* "A Fair in aid of the Industrial School for Crippled and Deformed Children will be held on Wednesday, November 22 at the Copley Plaza from 10 until 6 o'clock. It makes the first project to raise money for enlarging the present school building. Mah Jongg, bridge, whist and tea will be among the attractions other than the tables of fancy articles, flowers, fruit and vegetables, cake, candy and vases. There will also be a display of schoolwork to enlighten persons unaware of the unique school business. . . . Each chair in the school has an adjustable seat and back and is made to fit the exact requirements of its occupant. If a child seems ill in the classroom a nurse takes him out immediately, finds out the trouble and if the child needs treatment he has it without delay. This preventative care has meant a great deal."

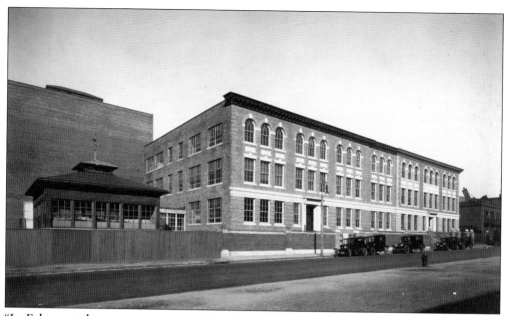

"In February the contracts were entered into with Messrs. Stone & Webster of Boston for the erection of the new building, which extends the facade along St. Botolph Street one hundred feet. The old building is to be used for school-rooms and the new for industrial training," stated the annual report of 1926. The entire addition to the school was made possible through a bequest from the will of Isabella Stewart Gardner, art collector and philanthropist.

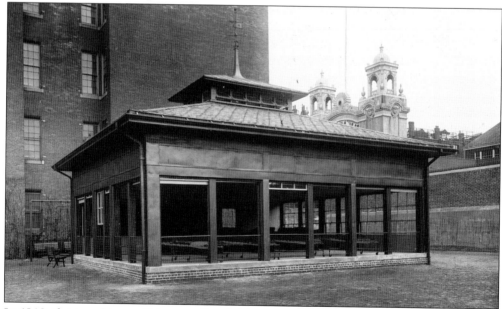

In 1912, the trend in medicine was for children to breathe as much fresh air as possible, which led the trustees to construct this open-air classroom on the school's playground. Cofounder Dr. Edward Bradford wrote, "it should be open from the roof to the ground. . . . You do not want any corner for any stale air to get in and rest . . . a room that the air will be going through all the time except when it is closed."

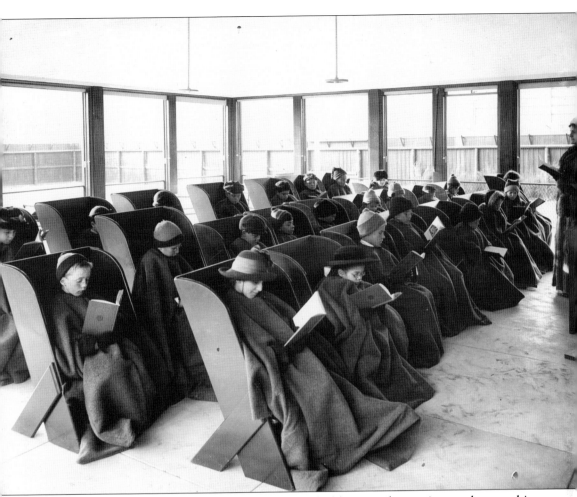

In the colder temperatures, children could not hold a pencil or write, so they read in the school's outdoor classroom. Cofounder Dr. Augustus Thorndike wrote, "There are two distinctly different ways in which the fresh air schoolroom can be made available for the pupils, all of whom may be regarded as more or less delicate children. First a small class should be segregated and put there for the whole or a large part of the day; this class needs to be selected by the physicians as most in need of the tonic of a fresh air school. . . . The other way would be to afford at least an hour of fresh air schoolroom for every pupil daily or on alternate days, weather permitting. . . . The advantage would be that the whole school would get the tonic effect of an extra hour of fresh air daily or every other day according as the administration or the weather might determine."

In 1923, Supt. Vernon K. Brackett wrote, "One of the greatest difficulties during the winter was the matter of transportation. Eleven days of school were lost on account of the bad condition of the streets. At the close of school only one omnibus out of the three was in fit condition to be used, the other two having been abandoned late in the season. Because of this it became necessary to close the Primary Room early in June. On account of the inadequate transportation service, and the loss of so many school days, it was thought advisable not to hold the picnic this year. In its place the school entertained the Czechoslovakian children of the Bakule School of Prague on May 24. The yard was decorated, and after singing and dancing by the visiting children, a collation was served."

In 1968, educational pioneer Ida Krebs founded Krebs Hall in Lexington, pictured above. Under the leadership of Supt. Dr. Carl Mores and board chair William O. Taylor, Krebs School merged into Cotting School in 1986. Two primary reasons contributed to the move to Lexington: the St. Botolph Street building required substantial, expensive renovations, and additional therapeutic and educational space was necessary for students with more complex medical and educational needs. Pictured here at the groundbreaking of the soon-to-be-expanded Krebs Hall site in April 1987, from left to right, are William Taylor, retiring board chair; Raymond Killian, incoming board chair; former superintendent William Carmichael; and Carl Mores. Construction was completed on budget and on time, and students moved into the new location in September 1988.

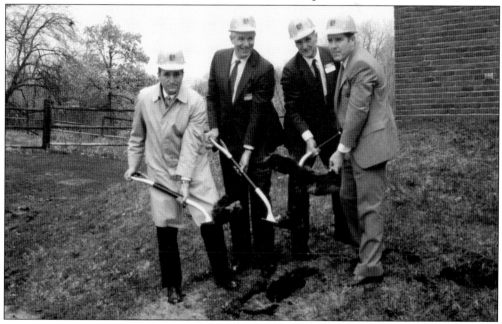

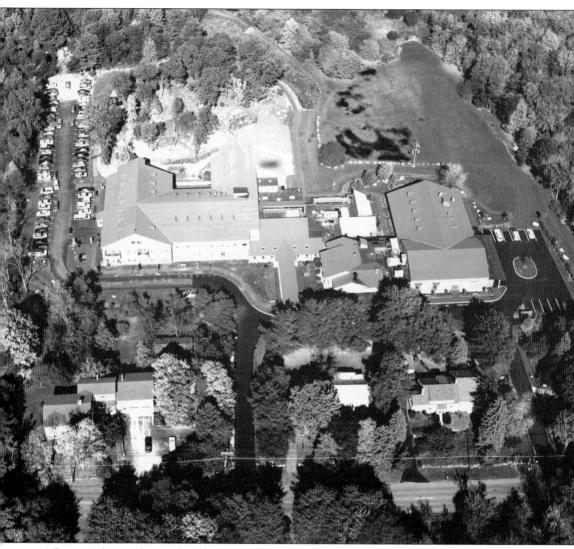

This aerial view shows the 14-acre Cotting School campus located at 453 Concord Avenue in Lexington. The main school facility is approximately 90,000 square feet. In addition, three buildings border Concord Avenue at the bottom of the photograph. From left to right are HOPEhouse, Carmichael House, and the Mary Perry Building. The facility is fully accessible and includes outdoor playing areas for the students. (Courtesy of Herb Gallagher.)

Four

HORSE-DRAWN CARRIAGES, OMNIBUSES, AND VANS

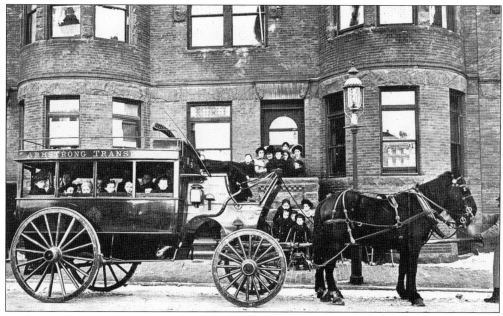

Students in horse-drawn carriages arrive at the school, then located at 424 Newbury Street. Boston routes included the West End, South End, and Roxbury carriage routes. Each one-way trip took 45 to 60 minutes. In 1898, trustee Francis Dumaresq wrote, "The ride . . . is the bright spot of happiness in the lives of these children, to whom a happy time is of rare occurrence. The coach and carriages have been furnished by the Armstrong Transfer Company; and the careful attention and kind personal interest shown by the drivers for the children, many of whom have had to be carried in their arms, has been a great satisfaction."

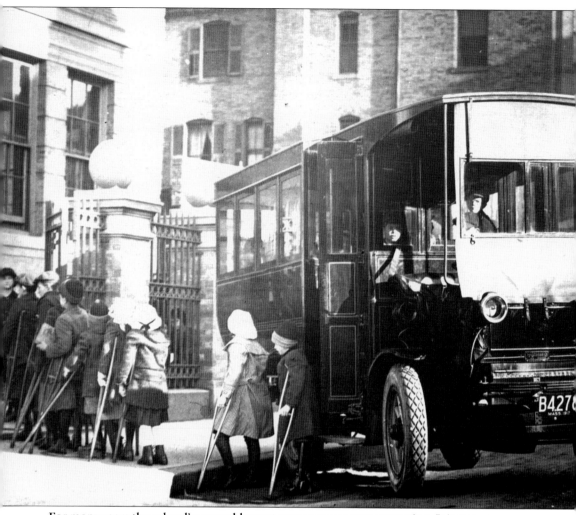

For many years the school's second-largest expense was transportation. It is not uncommon to find the following plea in the school's early annual reports: "a lady interested in the School gave one of the carriages; and if another year the School could be so fortunate as to have this generosity repeated for the sake of the children, it would be of very great help." This photograph was taken in front of the school, soon after it was built on St. Botolph Street in Boston.

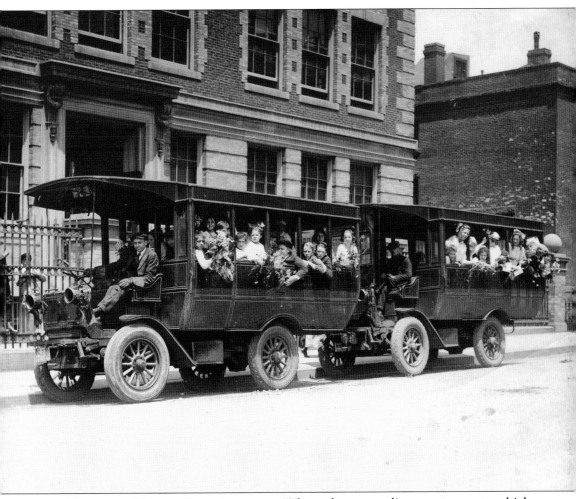

In 1923, trustee Thomas Cummins wrote, "The only extraordinary expense to which the School will be put at the moment is through the necessity of purchasing two new motor omnibuses to replace two out of the fleet of three which have become worn out from constant use during seven and eight years respectively. In spite of the original cost of the vehicles, it has been found that for the School to conduct its own transportation is more economical than the old system of renting vehicles and drivers. The cost of these will be about $14,000, and as the Trustees regret the diversion of so large an amount from the permanent funds of the School, although amply justified by the necessity, contributions toward this cost are suggested as appropriate to those who like to make their donations toward special objects."

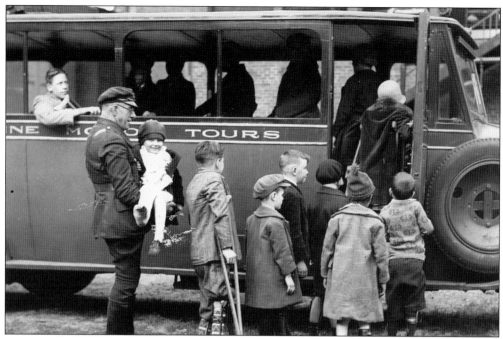

When September arrived, Gray Line Tours buses were no longer needed to transport tourists through the streets of Boston. Instead they were rented by the school to transport students. In this 1929 photograph, students board a bus from the school's parking lot on St. Botolph Street in Boston. With the extra care required of their duties, drivers were often called upon to carry children on and off the bus.

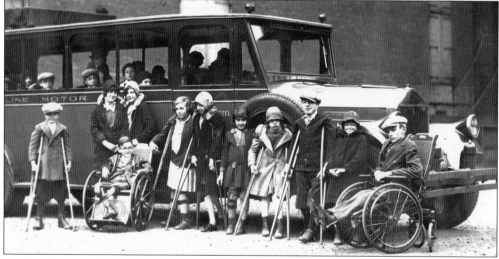

In this photograph from the 1930s, the school's students await a ride home. In 1929, Augustus Thorndike, the school's cofounder, shared an ongoing concern with the school's donors: "The transportation of pupils has always been a problem. A few children can and do go to and fro on trolley cars; most of them have to be hauled. In spite of gasoline replacing horses, the growth of the city in area and in population, and the increase of traffic-crowded streets have slowed transportation and made it more tiresome for the children, and more costly."

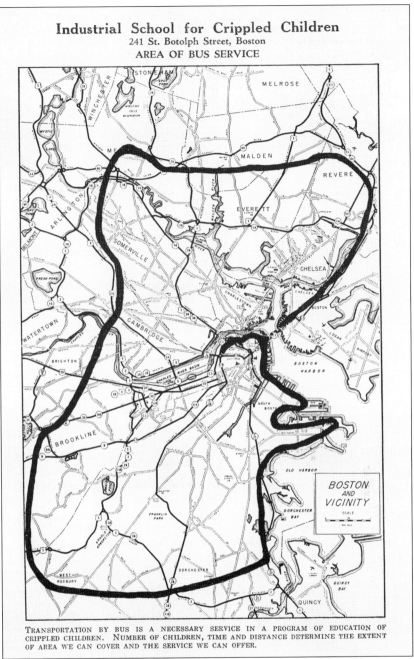

Industrial School for Crippled Children
241 St. Botolph Street, Boston
AREA OF BUS SERVICE

TRANSPORTATION BY BUS IS A NECESSARY SERVICE IN A PROGRAM OF EDUCATION OF CRIPPLED CHILDREN. NUMBER OF CHILDREN, TIME AND DISTANCE DETERMINE THE EXTENT OF AREA WE CAN COVER AND THE SERVICE WE CAN OFFER.

"Each child is brought to and from School in a well-heated bus with careful and considerate drivers and attendants. The limit of the area covered by these buses is determined by the distance from the School, the problem of getting the child on and off the bus, and the number of children on each bus. The trip has to be made so that the children can arrive at the School by the time of the opening of the morning session. In some cases, arrangements are made with parents so that children can be brought to some point within the bus area," stated Vernon Brackett in 1952. Today the school services 74 cities and towns in Massachusetts and southern New Hampshire.

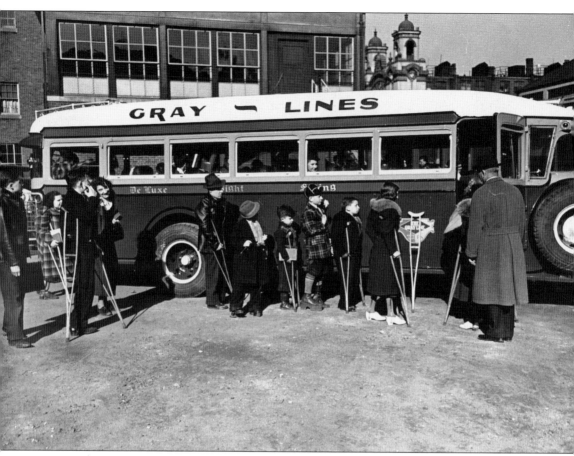

In 1954, Vernon Brackett stated: "A ride to school in a bus is quite common for most children at the present time due to the complexities of transportation, the luxuries of the time, and the desires of the people. For the crippled child it is a necessary factor. Without this service, many would be unable to attend. The bus represents in a small way for our children - adventure and pleasure. In real meaning it represents necessity and opportunity. With this service we are able to assist children from greater distance, who have not in the past been receiving the type of care and training best suited to their needs." In the above photograph, many of the students (on crutches due to polio) make their way up the steps of the bus. Note the facade of the old Boston Arena in the background.

By the early 1960s, the school was serving children from 38 cities and towns. In 1967, William Carmichael reported, "Our enrollment has nearly doubled over the past fifteen years, and transportation, next to salaries, is the biggest item of cost in the School budget. Presently we are using six buses, nineteen taxicabs and two private cars to transport the children from over forty separate communities. Some of our older students use the public facilities." The former open-air classroom can be seen in the background. With the 1926 building addition, the open-air classroom was enclosed, raised, connected, and converted into the Thorndike Music Center.

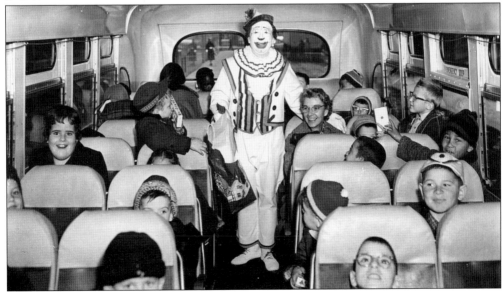

No clowning around! A special guest joined the students on a fun holiday field trip.

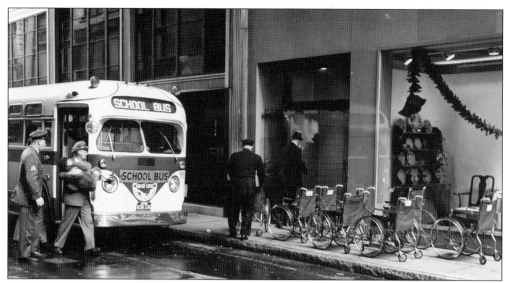

The Enchanted Village at Jordan Marsh signaled the beginning of the holiday season for generations of Bostonians. In this photograph a bus driver carries a student to her wheelchair parked outside the department store. The school's students attended the display, along with many other Boston children, as part of the annual holiday festivities.

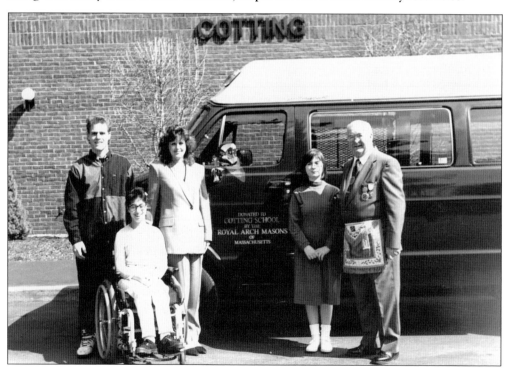

The Royal Arch Masons of Massachusetts have had a long history of supporting the transportation needs of Cotting School students. The vans are modified to accommodate students who use wheelchairs or walkers. Cotting's use of specialized transportation has expanded to include access to enrichment and educational opportunities and employment and internship sites through the school's prevocational Project Bridges Program.

Five

Sports, Recreation, and Outings

The stark language from the 19th-century school's logo may strike a 21st-century reader as offensive. Nomenclature has evolved and today few would consider using the words *crippled* or *deformed* to describe students with disabilities. But it is the Latin word *supra* and the inclusion of a drawing of wings in the school's first logo that capture the tenacity of the school's students to embrace life and work hard to overcome any obstacles to taking their rightful place in society. The sports, recreation, and outing photographs in this chapter capture the spirit of the school's students. Thomas Cummins, a trustee of the school for nearly 40 years, designed the logo.

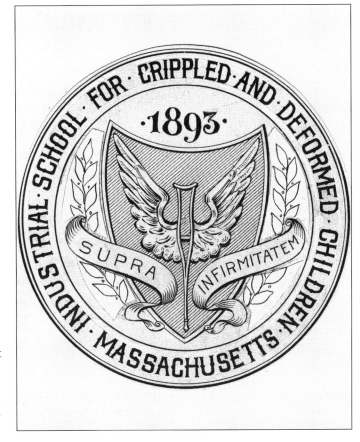

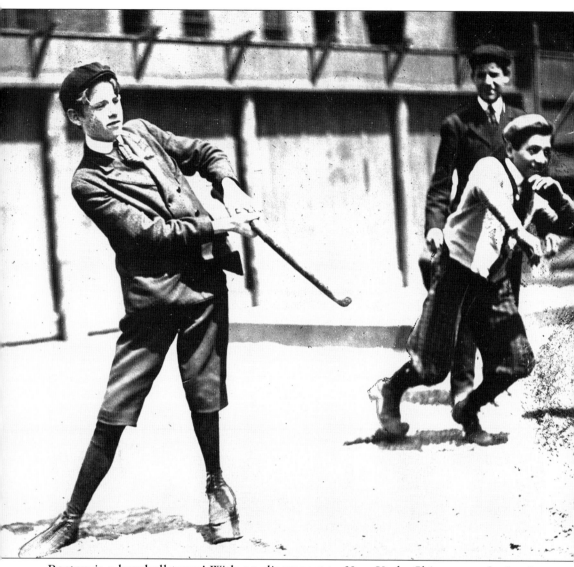

Boston is a baseball town! With no disrespect to New York, Chicago, or St. Louis, Boston fans have a unique love of the game. This early-20th-century photograph was taken on the school's playground. The school was located within walking distance of two major-league ballparks. The Boston Pilgrims, later known as the Boston Red Sox, played at the Huntington Avenue Grounds, while the Boston Braves, also known as the Beaneaters or the Bees, played at the South End Grounds III, located at the corner of Columbus Avenue and Walpole Street.

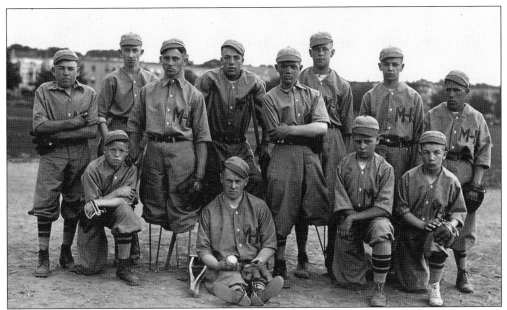

For many years, students from the Massachusetts Hospital School, pictured above, played the Industrial School at Franklin Park in Boston. Since Dr. Edward Bradford founded both schools, they share a unique history. The Massachusetts Hospital School is located in Canton, Massachusetts.

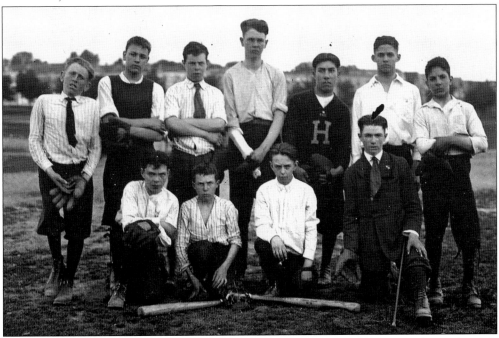

This photograph of the Industrial School's baseball team was taken in the early 20th century in Franklin Park in Boston on the day of the school's game versus the Massachusetts Hospital School. The park was named after Boston-born statesman Benjamin Franklin and is the "crown jewel" in Boston's Emerald Necklace, the park system created by Frederick Law Olmsted.

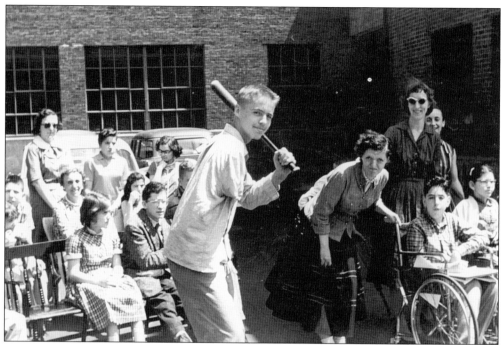

Throughout the years, baseball did not lose its appeal to the school's students. In this 1950s photograph, Bobby Pounder awaits the pitch. Pounder later owned a residential painting company in Maine.

The school was celebrating its 25th anniversary when the Red Sox won the 1918 World Series. Eighty-six years later, the "curse was reversed" and the Red Sox won again, sweeping the 2004 St. Louis Cardinals. As part of the Red Sox victory tour, the world championship trophy was brought to each classroom at Cotting School. Basking in the glow of the trophy are students in Kathy Hickey's classroom. (Courtesy of Ned Costantino/Sportshots.)

CRIPPLES REGISTER VICTORY

Mahoney, on Crutches, Scores in the Last Minute, 33-32

In language typical of the era, the following story appeared under a 1931 headline titled "Cripples Register Victory": "Probably one of the oddest spectacles in sports is offered by the Crippled Children's School basketball team. The crowd of youngsters who wear their school colors on the basketball court have a burden to carry, for each is handicapped physically. This club of game young kids rung up a victory yesterday 33 to 32 and the winning shot was made by Mahoney, the centre, in the last minute of play. There was no spectacular dash, dribble and shot in Mahoney's victory goal. There couldn't be, for the little fellow had a pair of crutches to contend with. . . . The game was close enough all the way. It was a ding-dong affair. The crippled lads might have lost heart at this and folded up. The fight they carried on to the finish proved that regardless of all else, they have sturdy young hearts."

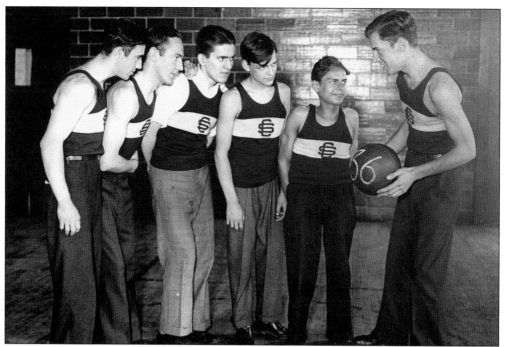

This photograph of the school's 1936 men's basketball team predates the founding of the Boston Celtics by 10 years. In later years, many of the Celtics stars, including Larry Bird, M. L. Carr, Satch Sanders, and Rajon Rondo, visited the school.

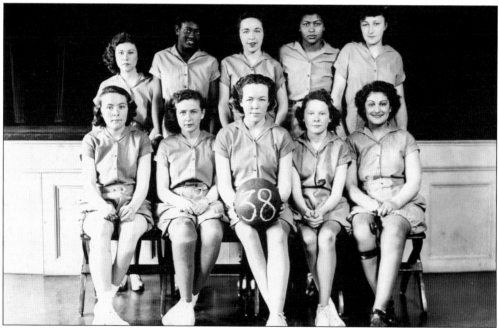

Ten students posed for the school's 1938 women's basketball team photograph. During this era, the team on the court consisted of six players from each school. Women's basketball was first played at Smith College in Northampton, Massachusetts, in 1892, one year after Dr. James Naismith invented the game in nearby Springfield.

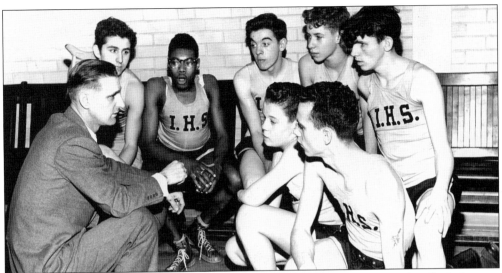

In this 1955 photograph, Supt. William Carmichael offers his words of wisdom to the school's team. John Chaves (back row, second from right) currently serves as a trustee of the school. During this era, Neil Singelais of the *Boston Globe* wrote, "There isn't a prouder basketball team than the one represented by the Industrial School for Crippled Children. . . . The boys on this exceptional team come from all parts of Greater Boston—will play a 19-game schedule against public and private schools as well as recreational groups. They'll be scrambling for baskets against youngsters who have no physical handicap. But the boys from the Industrial School neither ask quarter nor give it." (Courtesy of Parkway News Photo Service.)

In 2006, Douglas Belkin of the *Boston Globe* wrote, "In a packed gymnasium at the Cotting School basketball game one recent Friday night, three things were clear from the opening tip-off: the home team meant business; a little thing like muscular dystrophy can't keep a determined player off the court; and sometimes a small miracle and a 12- foot jump shot look an awful lot alike." (Copyright 2007, Globe Newspaper Company, republished with permission.)

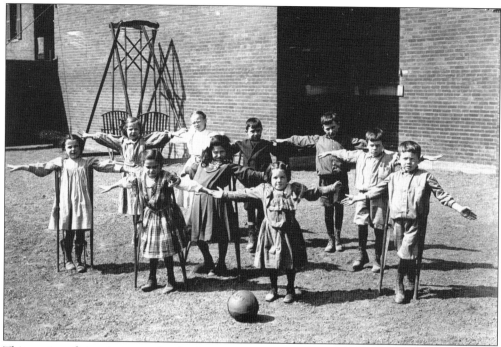

This series of six photographs depicts various sports that have been and continue to be played by the school's students. From calisthenics on the school's playground in this 1909 photograph to volleyball, floor hockey, soccer, and bowling, the school uses athletics to build self-confidence, camaraderie, and physical skills for its students.

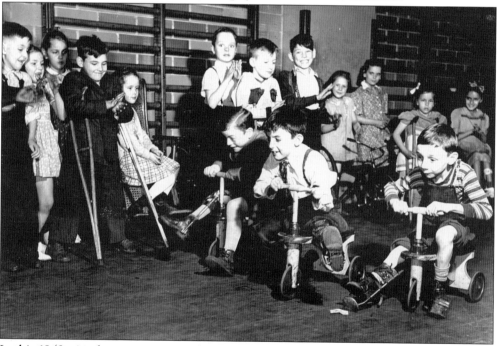

In this 1943 tricycle race, young students combine fun with physical therapy and adaptive physical education. (Courtesy of Arthur Griffin.)

Whether in the classroom or in the gymnasium, the students can be described by two seemingly opposite adjectives: tough and tender. There is tenaciousness in each child. The students have a fighting spirit, an "I can do it" toughness that has helped each one overcome seemingly insurmountable obstacles. At the same time, students treat each other with exquisite kindness. In these photographs, female students play spirited games of volleyball and floor hockey in the school's gymnasium.

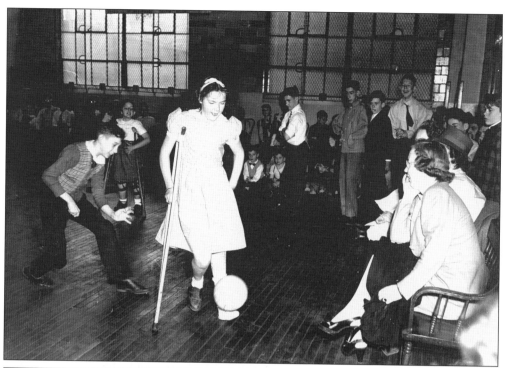

Parents, friends, and faculty members packed the gymnasium for this World War II–era soccer game. Neither crutches nor a leg cast held this young woman back from full participation. The school continues to have an active soccer program. In addition, students currently participate in golf, track, basketball, softball, skiing, and bowling. (Left, courtesy of Martha Stewart.)

In addition to the school's adaptive physical education department, it has affiliations with AccesSportAmerica, Massachusetts Special Olympics, and the New England Handicapped Sports Association. In the above photograph, two Cotting teammates celebrate after a Special Olympics Event. (Courtesy of Kathy Martin.)

A highlight of the school year for Cotting School students is the annual February student and faculty ski trip to New Hampshire. Thanks to the New England Handicapped Sports Association, students experience the joys of a New England winter. (Courtesy of George Moran.)

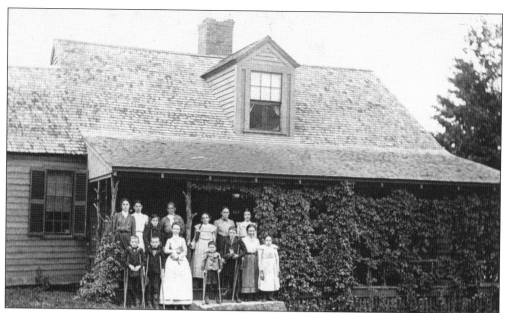

In 1900, students pose in front of the home of Mrs. E. C. Swift. Each summer Mrs. Swift treated students of the school to a two-week summer vacation at her home in Lancaster.

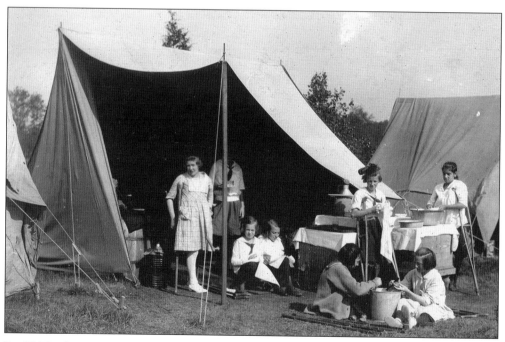

In 1908, the trustees retained Miss Knowles, the school nurse, to take charge of the annual summer outing. Each summer, the children visited Children's Island Sanitarium in Marblehead, Camp Hemenway in Canton, or other recreational areas in the countryside.

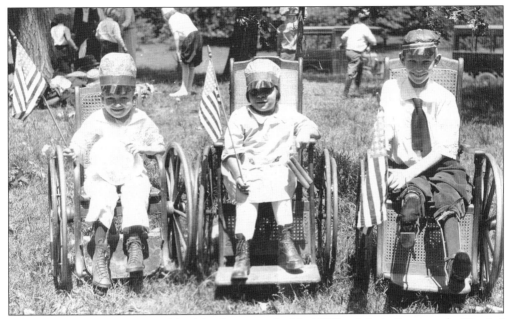

A 1920s outing was captured in this photograph titled "Wheelchair Cases at the Picnic." It was also used in a brochure titled "Life Stories, Written by Themselves."

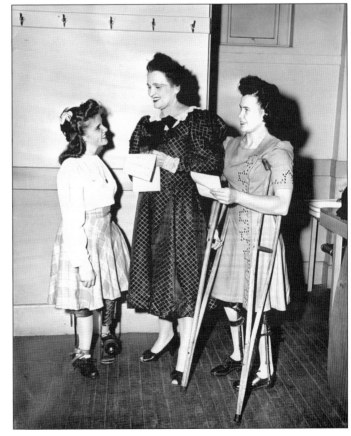

Prima donna Virginia Pemberton signs autographs for two students after a 1940s performance of *La Bohème* at the Boston Opera House.

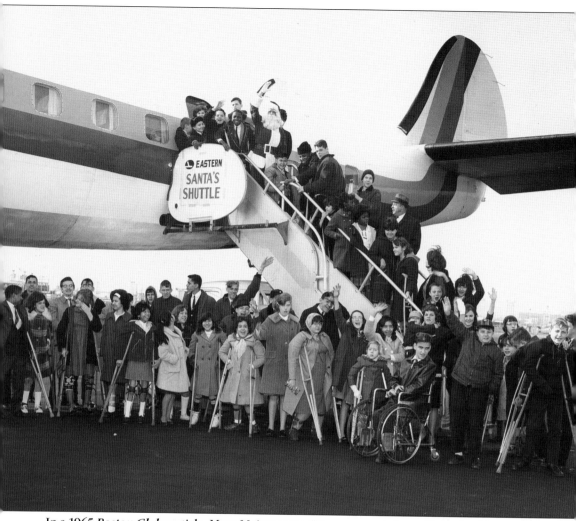

In a 1965 *Boston Globe* article, Mary Meier wrote, "For one magic hour Thursday 50 crippled children – who have never in their lives been able to run or skip—sprouted wings and flew. Fifth through twelfth grade pupils of the Industrial School for Crippled Children were guests of Eastern Airlines on a chartered flight that toured eastern Massachusetts from Ipswich to Provincetown." Rex Trailer, country-and-western recording artist and host of the children's television show *Boomtown*, joined the group as a tour guide.

Six

ALI, YAZ, BOBBY, AND OTHER FRIENDS

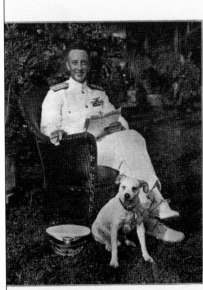

REAR-ADMIRAL RICHARD EVELYN BYRD

Rear-Admiral
RICHARD EVELYN

BYRD

will give his own account of the

FLIGHT TO THE SOUTH POLE

and tell the epic story of

LITTLE AMERICA

Illustrated By MOTION PICTURES

The Antarctic has kept her own secrets locked in her crystal citadel at the bottom of the world. Two men have struggled afoot to reach the centre of her stronghold—Amundsen, who returned to tell the tale, and Scott, who perished on his journey. Then Byrd, winged with the genius of man's invention, soaring over 1600 miles of glittering ice-bound silence reaches the Pole, straight as an arrow unswerving in its perfectly planned, perfectly timed flight. Here is a marvel to spur on the conquerors, and stir the imagination of all.

Having returned to North America on June 18, 1930, after his first of five explorations of Antarctica, Rear Adm. Richard Byrd gave a lecture on behalf of the school at Symphony Hall in Boston on October 16, 1930. Sarah Cotting, head of the school's entertainment committee and wife of the school's treasurer, arranged this successful fund-raising event. The lecture program states, "Rear-Admiral Richard Evelyn Byrd will give his own account of the flight to the South Pole and tell the epic story of Little America. The Antarctic has kept her own secrets locked in her crystal citadel at the bottom of the world."

One of America's most colorful politicians, James Michael Curley, received a cake on his 57th birthday, November 20, 1931, from six of the school's generous students during the heart of the Great Depression. After receiving the birthday cake, Curley called city censor John Casey to make arrangements, suitable to the officials of the school, to have all the pupils as his guests at a matinee in a nearby theater. Annually Curley invited the students from the school to join him at his March 17 celebration in South Boston. Known as the "Mayor of the Poor," Curley's affection for the students is obvious. At the time Curley was serving his third of four terms as Boston mayor. Curley also served two terms in the United States Congress and one term as governor of Massachusetts, as well as two stints in jail!

During the 1940s and 1950s rodeo championships were held at Boston Garden. As her classmates from the school looked on, a student sits astride Gene Autry's horse, Champion. She and her classmates were luncheon guests of Autry prior to attending a matinee performance. Known as the "Singing Cowboy," Autry was a film and recording star (*Rudolph the Red-Nosed Reindeer*) as well as the owner of the Los Angeles Angels.

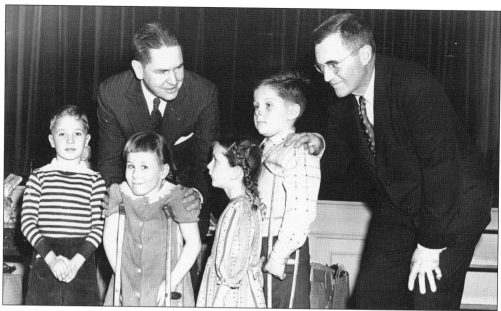

In 1947, Massachusetts governor Robert F. Bradford visited the school. With Charles H. Taylor Jr., president of the Cotting School Board of Trustees, looking on, he greets some of the school's younger students. Governor Bradford's father, Dr. Edward Bradford, was one of the founders of the school.

Similar to many of the school's students in 1960, Boston mayor John F. Collins had polio. At the beginning of his first term as mayor, he offered the following advice to the students: "The only real handicaps that exist are those of the mind and spirit. A physical disability can actually free us from mental and spiritual handicaps and thus open the door not only to worldly success, but also to great inner happiness—often greater happiness than those luckier than we can ever achieve. Those who have suffered hardest have had their emotion stretched—their feeling sharpened. Thus they can often rejoice the hardest when the occasion arises." The mayor's visit took place during the era when impressive breakthroughs were being made to combat poliomyelitis. Jonas Salk and Albert Sabin were developing vaccines to help future generations of children.

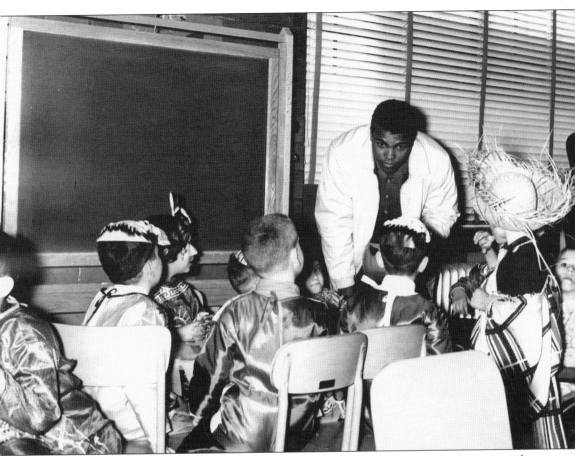

In 1964, while in Boston preparing for a rematch with Sonny Liston, heavyweight boxing champion Muhammad Ali celebrated Halloween with students at the school. Ever the promoter of tolerance and understanding, Ali accepted an invitation to speak with the students. Comedian and actor Stepin Fetchit accompanied Ali. Jim Tanner, then a sixth-grade student at the school and currently on the school's faculty, remembers that Ali was training in the old Boston Arena. During his visit to the school, Ali wore horseshoes on the bottom of his shoes as part of his weight-training regime. Former superintendent William Carmichael recalls the clopping sound Ali made as he walked. The arena, which was used for hockey (Boston Bruins), prize fighting (Joe Louis and Jack Dempsey), and political gatherings (Teddy Roosevelt and John F. Kennedy) was located directly across from the school on St. Botolph Street. The school had been built in 1904 and the Boston Arena five years later.

Stage and television star Patty Duke, pictured with Supt. William Carmichael, visited the school in 1965. Duke was active in many organizations that provided better understanding and support for individuals with disabilities. Her Academy Award–winning performance in *The Miracle Worker* brought the accomplishments of Helen Keller and her teacher, Anne Sullivan, to life for many, thereby increasing the cultural understanding of the potential of children and adults with disabling conditions. Her disclosure of her own bipolar disorder has extended that effort into the present.

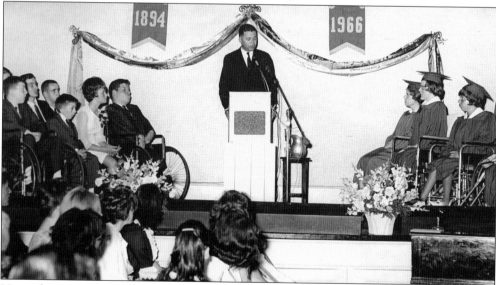

Massachusetts attorney general Edward W. Brooke was the commencement speaker at the school's June 8, 1966, graduation ceremony. During his address, he stated, "It is a distinct privilege and pleasure for me to be with you on such a memorable occasion and to witness the outstanding achievements of the School and the wonderful students. . . . I have only the greatest admiration for the superior education which the faculty is providing for these children." Later Brooke became the first African American senator elected by popular vote in U.S. history.

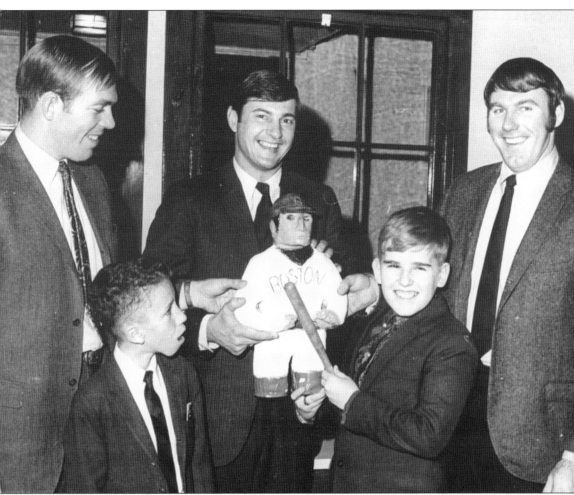

Two sixth-grade students presented Boston Red Sox star Carl Yazstremski a sculpture of a baseball player they had made at school. Joining "Captain Carl," on the left and right are Red Sox pitchers Bill Landis and Sparky Lyle. The players toured the school and then held a baseball information session in the dining room. The 1969 Red Sox team finished third in the American League that season, two years after Yazstremski's "Impossible Dream" most-valuable-player season when he led the team to the World Series. At the time, the school was located within walking distance of Fenway Park.

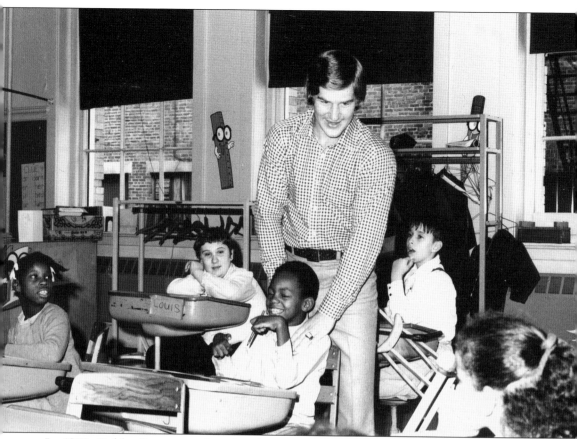

In 1973, Bobby Orr—two-time Stanley Cup winner, Hockey Hall of Fame member, and Boston sports legend—made one of his frequent visits to the school. Orr's ease in meeting with the students and their admiration for him is evident in the above photograph. Orr often called Supt. William Carmichael to ask, "When can I come over and see the students?" Orr was a loyal champion of their needs, both in the classroom and at fund-raising events. In 1970, the Stanley Cup was brought to the school. Former superintendent Carmichael recalls, "I had each kid hold it. It went back with peanut butter and jelly fingerprints all over it."

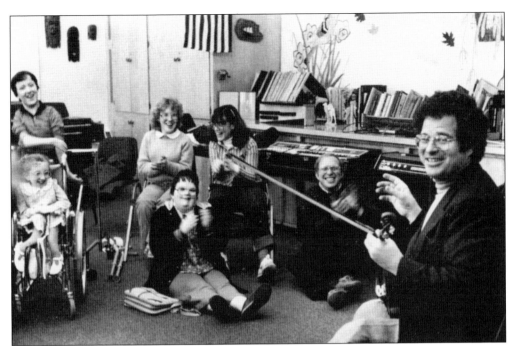

Israeli American virtuoso violinist and multi–Grammy Award winner Itzhak Perlman performed for students in teacher Noreen Murphy's music class in the school's Thorndike Music Center. Considered the most distinguished violinist of his era, Perlman's visit was part of the school's commitment to providing quality music and art education to its students, as well as exposing the students to successful adult role models with disabilities.

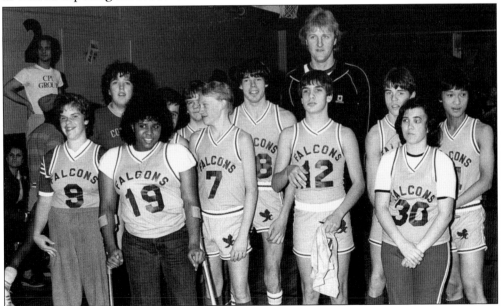

The Cotting Falcons joined students from across the city for a basketball demonstration by Larry Bird at the Huntington Avenue YMCA. Bird, a three-time NBA most valuable player and three-time NBA champion, took a liking to the young stars and joined the school's team photograph.

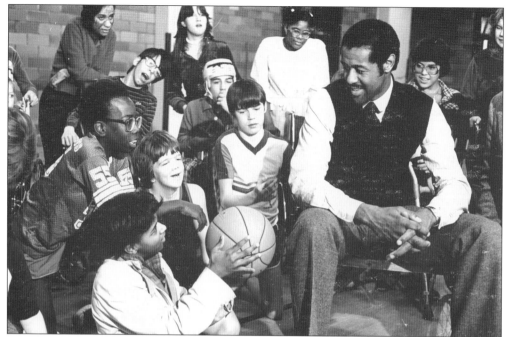

As teacher and coach Jim Tanner was preparing the Cotting School basketball team for a Friday night game, he noticed M. L. Carr of the Boston Celtics entering the Boston Arena across St. Botolph Street and invited him to the school. Ever ready to assist, Carr held an impromptu scrimmage with the Falcons. Carr went on to win two NBA championships with the Boston Celtics.

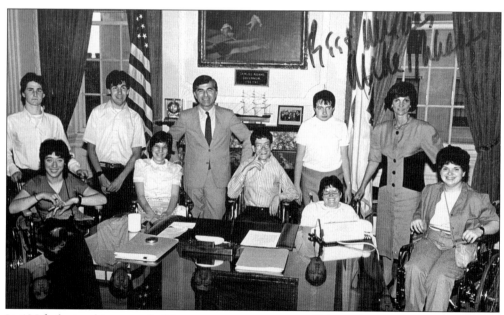

In 1986, during his second of three terms as governor of Massachusetts, Michael Dukakis hosted Cotting School students in his office at the Massachusetts State House. First Lady Kitty Dukakis joined the governor in welcoming the group.

Jean-Michel Cousteau, founding director of the Cousteau Society, is pictured at right with the school's president Dr. Carl Mores at the Seamark fund-raising event at the New England Aquarium in 1991. The Seamark event supported Cotting School's efforts to provide quality vision services to children with severe special needs.

In a campaign to raise funds for its students' needs, the Cotting League of Athletic and Science Partners held a Boston sports legends evening at the Museum of Science in 1995. From left to right are (first row) Carl Mores, president of Cotting School, Ken Meyer, and Alice Cook; (second row) John Hannah (Patriots), Joe Castiglione, M. L. Carr (Celtics), Dan Shaughnessy, Bill Rodgers (Boston Marathon), Johnny Pesky (Red Sox), and Ken Hodge (Bruins).

Cotting teacher Sejal Shah's middle school class met with Massachusetts governor Deval Patrick outside the Massachusetts State House in 2007. In 2005, the Cotting School Government Affairs Committee, comprised of faculty and parents, sponsored "Invite Your Legislator to Cotting School Day." Forty-eight Massachusetts state senators and representatives and their aides visited the students in their classrooms at the school. In 2007, students from Cotting School continued their conversations about the importance of special education with government officials during visits to the Massachusetts State House. (Courtesy of Bridget Irish.)

Seven

COTTING SCHOOL TODAY

Today Cotting School serves students whose needs require comprehensive and individualized instruction and intervention based upon physical, medical, and/or learning disabilities. Components of the program include academic instruction, adaptive physical education, adaptive equipment and materials, career awareness and prevocational instruction, reading and math tutorial, counseling and social skills training, daily living skills training, dental services, feeding and dietary services, medical services, occupational therapy, personal care services, physical therapy, speech and language therapy, consultation and outreach, and vision services. Cotting School's commitment to the whole child includes working in partnership with parents and families. The following photographs represent a sampling of Cotting School's current services. (Courtesy of Martha Stewart.)

Academics are the solid foundation of a Cotting education. Educational goals and objectives are developed and implemented within the framework of an individualized educational plan. The curriculum follows the Massachusetts Curriculum Frameworks, and students are taught in classrooms organized in lower, middle, and upper schools. Above, a lower school student works on phonics skills with his teacher Mike Teuber. Cotting prides itself on its exceptional teachers like Teuber, who is a third-generation educator. Classes at Cotting School are small, and education is the balance between meeting academic goals, building social-emotional skills, and helping students become more independent. Cotting School also offers a two-year teaching fellowship to recent graduates from highly regarded schools of education throughout the United States. This is an example of Cotting School's commitment to training the next generation of highly qualified teachers entering the world of special education to serve America's most challenged children. (Courtesy of Martha Stewart.)

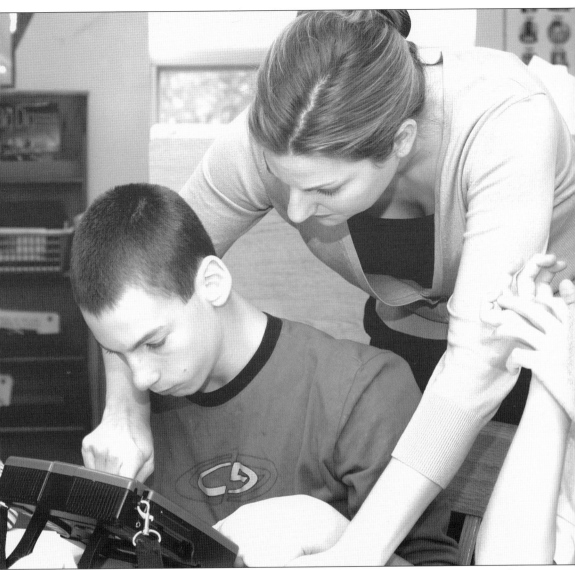

Communication Therapy and Technology are integrated throughout Cotting's curriculum. Assistive technology devices can make learning not only easier but possible. They enrich language skills and increase independence. Students use the latest equipment to improve skills in all content areas. Computer-assisted art helps students with limited mobility to share their creative ideas. From the music studio to the classroom to the Pace Assistive Technology Assessment Center, therapists and teachers provide a wide range of technological opportunities for the students. Augmentative communication devices, such as the one communication therapist Karen Waddill is programming here with a student, enable Cotting students to maximize communication and computer use both at school and at home. (Courtesy of Martha Stewart.)

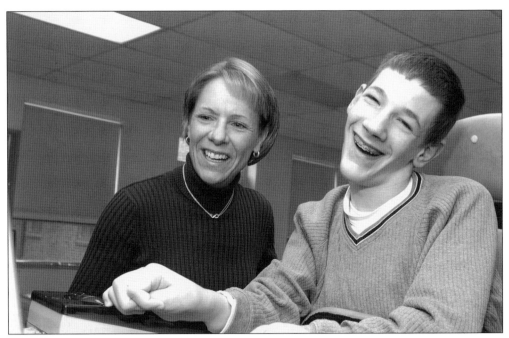

Cotting's occupational therapists address students' upper extremity motor performance, basic sensory functioning, visual perceptual and visual motor skills, and the ability to plan tasks for classroom success and activities of daily living required for independence. Physical therapy addresses motor skill performance in a range of areas and is primarily offered to students who have orthopedic or neurological challenges that affect school performance. Therapy services are provided as part of each student's individualized education program. Regardless of the setting, therapists such as Amy Houghton (above) and Ginny Birmingham (left) make these sessions fun and integrated with learning. (Courtesy of Martha Stewart.)

Dr. Laurie Glader (left), medical director, and Michele Cardalino (center), medical team leader, meet with a student in the school's medical department. Cotting School offers medical, dental, vision, and feeding team services. The school is affiliated with Children's Hospital, New England School of Optometry, and Tufts School of Dental Medicine. Nurses distribute medications, assist students with personal care, provide tube feedings, chart observations, consult with parents and teachers, and respond to a range of medical issues. The Seamark Vision Clinic offers optometric testing and vision services, while the dental clinic provides dental care and oral hygiene training. The Cotting School interdisciplinary feeding team ensures a safe eating environment for all students, while supervising children at risk of choking and helping students who require assistance with feeding. (Courtesy of Martha Stewart.)

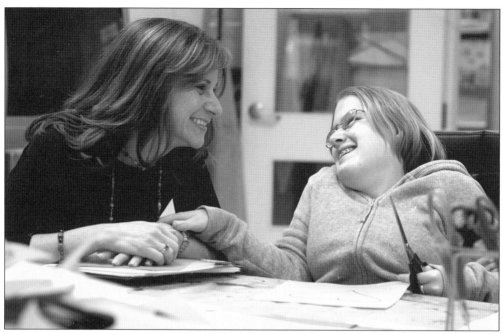

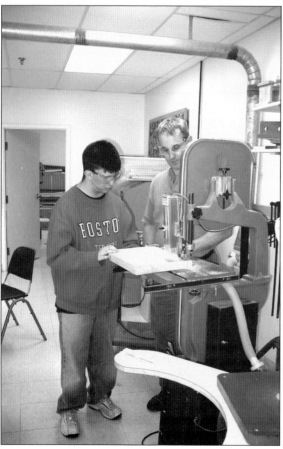

Visual/creative arts and industrial arts have been students' favorite classes since the school was founded. In the photograph above, art teacher Rosanne Trolan works with one of her upper school students. Students hold a highly regarded art exhibition annually. In addition, their work is displayed at local businesses. Industrial arts provides useful vocational skills and increases coordination. At left, an upper school student builds new benches for the basketball team with Bill Phelan. The school offers a variety of enrichment classes in addition to industrial arts, including music, adaptive physical education, library/media, home economics, and after-school extracurricular activities. Each year the senior class travels to Disney World and upper school students are given the opportunity to participate in a three-day ski trip to New Hampshire. (Above, courtesy of Martha Stewart; left, courtesy of Elizabeth Campbell Peters.)

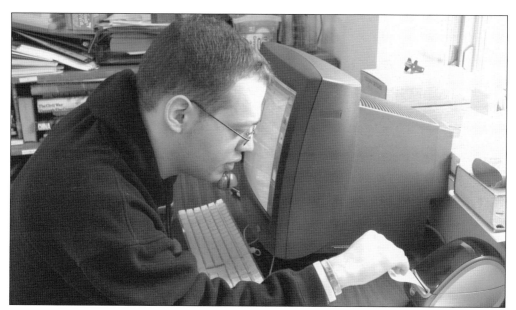

Cotting School provides many opportunities for students to set their own attainable goals for future educational, vocational, and living experiences. For middle and upper school students, the Work Skills Program offers a variety of on-campus prevocational opportunities as part of an integrated curriculum. Courses and instruction help students develop good work habits and skills. The student in the above photograph prepares a book for shipping from the Cotting School Storefront at Amazon.com. In this role, students catalogue books, upload information, and price and ship books for sale across the United States. (Courtesy of Elizabeth Campbell Peters.)

Cotting School is open year-round. In the summer, students are offered academic instruction as well as a variety of specially designed programs, such as Summer Adapted Living Skills Experience (SALSE), which is pictured at right; Skills For Life; Community Work Program; and Vocational Explorations. Students develop skills and expand career awareness and adaptive living skills through academic and work experience both on campus and throughout the metropolitan Boston area. (Courtesy of Scott Gray.)

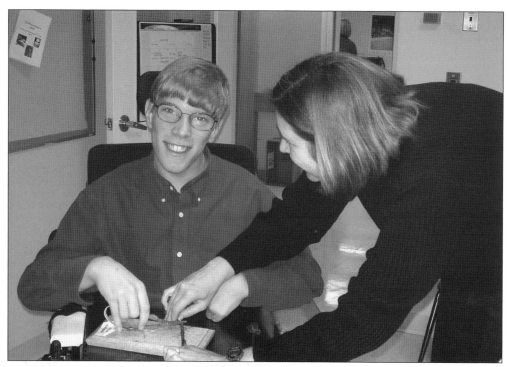

Experience-based learning programs offer students opportunities to examine and explore work environments in the community. Project Bridges places upper school students in community-based internships. In the photograph above, Audra Hamilton, an occupational therapist, works with a student as he cuts and arranges flowers, which he will later distribute to residents at a local nursing home. At left, a student prepares salads for customers at a local restaurant. Both jobs prepare students for life after Cotting School. (Courtesy of Elizabeth Campbell Peters.)

The Cotting School tradition includes student advocacy and community education as well as outreach and training to other schools and students. Above, a student uses her assistive technology device to communicate with her state representative George Peterson. In an ongoing effort that began in 2005, students have met with more than 48 legislators and aides at Cotting School and at the Massachusetts State House. The visits are tied to the curriculum and make democracy come alive. The boys and girls shared their accomplishments and school pride while practicing the self-advocacy skills they learned at Cotting School. (Courtesy of Martha Stewart.)

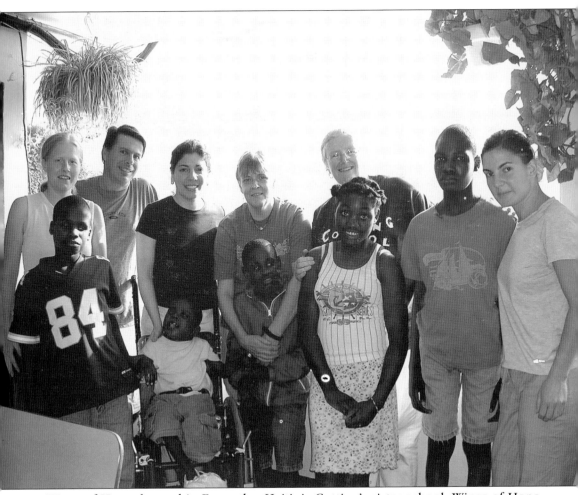

Wings of Hope, located in Fermathe, Haiti, is Cotting's sister school. Wings of Hope serves children with special needs who have been abandoned. The staff from each school exchanges educational strategies. As part of Cotting's continuing outreach efforts, staff travel to Haiti to provide direct care to children as well as mentor Wings staff. In addition, students from both schools enjoy each other's cultures and share ideas through e-mails. Although Wings has no running water and electricity is limited to two hours per day, children receive quality residential care and educational services. In the above photograph, K. C. Bersch (far left), director of education at Wings of Hope in Haiti, and five of her students pose with Cotting School staff members. From left to right next to K. C. are David Manzo, Krista Macari, Cathy Mayo, Ginny Birmingham, and Stephanie Gulla.

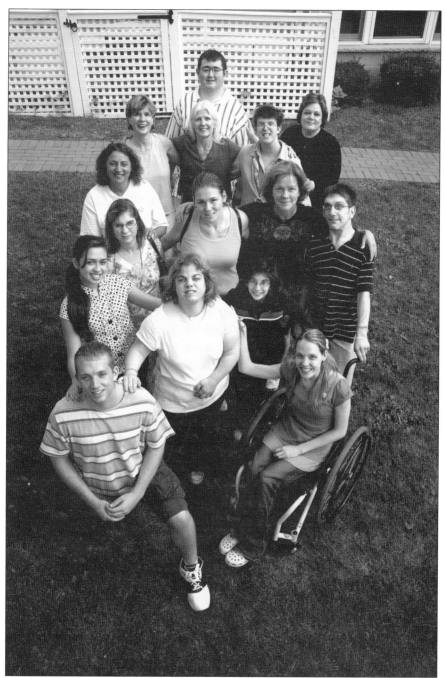

HOPEhouse, Cotting's residential program for eight young adults ages 18 to 28, lives its motto, Where Hope Meets Opportunity. At HOPEhouse, young adults receive live-in training and supervision, educational and vocational experience, and a variety of clinical services, including nursing, occupational therapy, speech therapy, and/or physical therapy. HOPEhouse residents have physical or learning disabilities; although they may have completed high school, they benefit from continued social, educational, and vocational support as they move toward independence. (Courtesy of Martha Stewart.)

Discover Thousands of Local History Books Featuring Millions of Vintage Images

Arcadia Publishing, the leading local history publisher in the United States, is committed to making history accessible and meaningful through publishing books that celebrate and preserve the heritage of America's people and places.

Find more books like this at
www.arcadiapublishing.com

Search for your hometown history, your old stomping grounds, and even your favorite sports team.